序文

　　從事設計 30 年是個漫長的路程，在設計的路程中
免不了會遇到瓶頸或挫折，如果有一股對設計的熱誠
與執著，就會創造出令人心動的作品，本書雖說是呂
總監的作品集，但這也代表著呂總監這 30 年來的心路
歷程。我對呂總監的第一印象是溫文儒雅的設計師，
在和藹的外表下，內藏著呂總監對設計的熱誠以及尋
求設計創作樂趣的執著。

　　呂總監從國立藝專（國立台灣藝術大學的前身）
畢業後，一開始即投入設計實務工作，並為了追求更
高一層的設計理念遠赴美國求學，進而在美國設立設
計公司來磨練自己的設計之路，於 1993 年返國成立
呂豪文工業設計有限公司。因為呂總監對設計的堅持
與厚實的素養，使得呂總監屢獲國際獎項的肯定，從
台北電話亭國際設計競賽，台北新公園 228 紀念碑競
圖到城市車設計競賽都有其獲獎的佳績。在那個舉辦
競賽不多的年代，呂總監的表現實屬難得。近年來呂
總監更投身教育，希望以多年的實務經驗來傳承與開
導莘莘學子，所以呂總監是少數目前還在橫跨實務與
學術界的設計大師，而他那份天天做設計，天天創作，
也天天傳遞設計與教導學生的設計之心，也促使他把
設計當成他的生活重心之一。

　　所以觀看本書不但可以看到一個創作的圖集，還
可以看到呂總監設計的心路歷程以及每個階段的轉
變，從而理解設計之路的艱辛與堅持的重要，而呂總
監以本書是其個人的期中報告而自我定位，相信在未
來將會有更盛大的火花呈現給設計界，而在此台灣辦
理 2011 台北世界設計大會的時機，本書的問世也為
默默付出的台灣設計師寫下一個註解，也期望促使台
灣的設計產業邁向更蓬勃發展的康莊之道。

台灣創意設計中心執行長　張光民

Foreword

Working in design for thirty years is a long journey. There
have been obstacles and frustrations, without passion
and dedication there would not have touching works. This
book is the portfolio of Lu's design works and represents
his internal struggles in thirty years. My first impression on
Lu is that he is a gentle and decent designer. Underneath
his amiable appearance lie his passions to design and
dedication in pursuing pleasure of creation.

After graduating from National Academy of Arts (former
National Taiwan University of Arts), Lu immediately
committed himself to design practice. To pursue advanced
study in design theory and better design practice, he then
studied in the USA and established his own design company.
In 1993, Lu returned to Taiwan and founded Wen's Design
Inc. Because of Lu's solid quality and insistence on design,
he was frequently recognized by international design
awards, including International Design Competition of Taipei
Public Phone Booth, International Design Competition of
Taipei 228 Monument and City Car Design Competition. His
excellent performance was uncommon at that time when
the winning chance was rare. In recent years, Lu has been
devoting himself to education, aiming to convey his years'
of experiences to young students. Lu is one of the fewer
design masters whose fields of expertise go across practical
and academic world. Design is Lu's everyday focus; he
designs, creates, enlightens and teaches students with a
heart of design.

This book is not only a portfolio but also a documentation
of Lu's design process. Readers will be able to see Lu's
transitions and internal struggles from time to time and
further understand how greatly he has been devoted
himself to design. Lu positions this book as his personal
midlife report. It is believed that in the future Lu will present
more astonishing works to design industry. At the moment
when Taiwan is hosting the 2011 IDA Congress, this book
commends Taiwanese designers for their devotions in
the hope to promoting Taiwan design industry toward a
prosperous future.

Taiwan Design Center, CEO, Tony K. M. Chang

「交鋒」下的「循理開物」

2011即將在台北市舉辦的世界設計大會，以「Design at the Edges」作為大會主題，中文則以「交鋒」來表達設計與各領域的互動。設計在面對「Design at the Edges」的挑戰時，必需認清這是傳統與現代的「交鋒」，也是科技與人文的「交鋒」，更是感性與理性的「交鋒」。因此，當設計面對跨界、跨領域或異業結盟的「交鋒」時，如何透過理性思考來激發設計創意，並透過感性造形來感動消費者，就益形重要。呂豪文設計總監將其個人30年的設計經驗，依其「循理開物」理念產出作品，整理成設計專輯，所呈現的正是「交鋒」下的理性與感性交融的設計思維，這也是本人樂於推薦本書的原因。

從設計是有目的、有條件、合理化與創造性的綜合造形活動，講求「人與物」互動的「社會性」；到結合「物理機能」與「心理機能」的「合理造形」，注重「人機系統」，考慮「人因工程」；最後，把設計納入「經濟活動」，營造「生活型態」，形成「生活文化」，達到「人性化」的生活環境。呂豪文設計總監充份掌握社會文化的脈動，以「循理」作為創新組合的設計思維，透過「開物」形塑優質的生活文化。

就文化創意產業設計而言，「文化」是一種生活型態，「設計」是一種生活品味，「創意」是經由感動的一種認同，「產業」則是實現文化設計創意的媒介、手段或方法。因此，就文化的層面來看，設計透過文化創意經由產業實現一種設計品味，形成一種生活型態。文化是花錢的產業，產業也可成為賺錢的文化。文化創意表現在設計產業的關鍵，就是經由「循理開物」來達成文化創意的目的，這也是呂總監透過本書所要表達的「始於文化，形於產品，用於生活」的設計哲理。

過去產品的設計思考，著眼點一切為「功能」（use），未來創意產品的設計思考，其主體則是「人」（user）。創意產品講求「藝術」的美學特色，工業產品講求「標準」的科技規格，差異在「藝術」的美學特色是對「人」的要求；「標準」的科技規格則是對「物」的品質管制。創意產品是「人性」的表現，工業產品是「物性」的追求；創意產品是「感性」的訴求，工業產品是「理性」的需求；創意產品注重的是「故事性」，工業產品追求的是「合理性」。呂總監的「循理開物」透過設計實例，所呈現的正是上述設計思維的交鋒；提醒我們需要思考的問題是：如何在「交鋒」下「循理開物」，發揮「Design at the Edges」的功能。

假如您同意上述的觀點，那您不能錯過「循理開物」。

國立臺灣藝術大學 設計學院院長 林榮泰
2011 年 8 月

Xun Li Kai Wu at the Edges

The theme Design at the Edges (Jiao Feng) of the upcoming 2011 IDA Congress literally means the interaction between design and other fields. While facing the challenges at the edges, we must recognize it is the edges of the traditional and the modern, the edges of technology and humanity, and the edges of sense and sensitivity. It is relatively important to motivate creativity through rationality, and touch consumers' hearts by sensitive forms while design encounters the edges of crossover or tie-in cooperation. Lu Haur-wen designs with the concept of Xun Li Kai Wu and compiles his over-30-year design experience into a portfolio, presenting the embodiment of sense and sensitivity. Therefore I would like to recommend this book.

Design is a synthetic activity that comes with purposes, conditions, reasons and creativities. Design is particular about the sociality of people and objects. Design combines physical and mental functions with rational forms. Design focuses on human-computer system and considers human factors engineering. At last design is included into economic activities so that lifestyle and living culture is developed, and the living environment becomes user-friendly. Lu grasps social and cultural trends well; he applies Xun Li (follow rationality) to originate innovative design concept and shape excellent living culture through Kai Wu (create objects)

In regard to design and creative industry, culture is a type of lifestyle and design is a taste of life. Creativity is an identification shaped with touching emotions and industry is the means, medium or methods of the realization of culture, design and creativity. Therefore design can realize a lifestyle and a taste of design through culture and creativity. Culture is a costly industry; industry can be a profit culture. The key of presenting culture and creativity to design industry is through the process of Xun Li Kai Wu, which is Lu's design philosophy "Started at culture, formed through products, used for life" expressed in this book.

In the past, design thinking focused only on "use"; however, design thinking of future creative products will focus on "user". Creative products emphasize on the aesthetic characteristics of art; on the contrary, industrial products emphasize on standardized technology specifications. The difference is aesthetic characteristics of art requires "human" factors but standardized technology specifications are quality control of "objects". Creative products are the expressions of "humanity"; industrial products are the pursuit of "objects". Creative products appeal for "sensitivity"; industrial products fulfill the needs of "reason". Creative products focus on "story"; industrial products focus on "reason". Lu's Xun Li Kai Wu presents design works developed and realized through the above interactions. It reminds us to think of adopting Xun Li Kai Wu at the edges and fulfill the functions of Design at the Edges.

If you agree with the above viewpoints, then you will not miss Xun Li Kai Wu…

Lin Rungtai
Dean, College of Design, National Taiwan University of Arts
Aug., 2011

自序

從事實務設計已近三十年，從早期任職於聲寶電器公司以及紐約 ROBESON 工業公司，擔任所謂的 IN HOUSE 設計師以外，其餘的時間均投入自己經營的設計公司，從事設計服務的業務，這是因為喜歡一份自由及可以接觸較廣的領域。而有關實務設計涉及的相關製造技術、加工過程、構想表現、產品開發程序，甚至於設計理念等主要基礎概念都是在聲寶公司上班時期養成的，這個基礎的養成直到現在還在持續的影響，沒有這個基礎，在未來實務設計的發展上，必然會遭遇到更大的困境。

第二個主要的影響是在辛辛那提大學設計學院攻讀碩士期間，以研究途徑解決設計問題的體驗，這段期間觸及到設計理論的形成形式以及設計方法的整理應用等等，我在聲寶上班時期所發展的「方形四分法」在辛辛那提大學設計學院透過實證性的研究方法，獲得證實是可行的方法，「循理開物」的設計理念，也是在這段期間形成更完整的架構，更確定了往後走向理性的設計語言方向，以及引導走向更深度探究事理的根本與企圖。第三個影響是在 1990 年於紐約成立 WEN'S 設計公司，承接了大量的 POP（POINT OF PURCHASE）的設計業務，POP 可說是市場及行銷企畫最後落實的展現，不同類行的產品、不同的品牌、不同的賣場、不同的主題、不同材質的搭配應用、不同的加工技術等等，都必須依據一定的途徑與程序進行，如此多樣性的磨練，對後來走向更寬廣、更實際的設計領域，有很大的助益。而在大量發展 POP 構想草圖過程中，逐漸體會到以目測直覺畫出精準透視的重要及必要性，我最近在整理目測透視圖法的大部分內容，都是在這個時期理解的。

1993 年 WEN'S 設計公司正式以產品開發相關之設計服務對外營業，秉持「循理開物」之設計理念，以戰戰兢兢的務實態度，協助客戶廠商開發設計產品以贏得市場競爭一直是最重要的目標，能與客戶、廠商分享市場成功的喜悅是非常有意義的事，也代表 WEN'S 設計公司存在的價值。

1999 年 9 月 WEN'S 設計公司創立 IDECO 品牌，強調品質、生活及創意為品牌經營理念，文具及家用品為主要開發項目，鋁為主要材質，歐洲為主要市場，以累計專利超過百件，IDECO 品牌的建立與經營強化了 WEN'S 設計公司市場的實務經驗及增加了歐洲諸多廠商成為 WEN'S 設計公司設計服務的對象。

這本書是以個人設計專輯目以年代後先順序的形式呈現，因此這本書不完全代表 WEN'S 設計公司的所有作品，如果非本人之原始創作之作品，則不在本書內容呈現。其中，有些作品如參與之設計師，在 3D 建構或是在設計過程中提出具有較大建設性之思考者，則列名為合作之設計師。另外，有些作品涉及工藝師之工藝工法加持而提高價值者，亦列名為合作之工藝師。對本書所列舉之相關廠商客戶、製造商、單位及參與設計師等，在此致上最高的敬意，尤其是惠予創作機會之廠商單位，特別的感謝。

這本書是不惑之年的作業整理，一份期中報告，雖是過去將近三十年個人累積的作品集，但其中，較大的部分都是跟隨台灣產業發展的脈絡而呈現，似乎也可窺知一二有關過去台灣設計發展與產業之間的互動面貌。一件產品的形成，往往是當時社會、經濟、文化、技術等多元發展的縮影，而生於斯，長於斯之設計創作養分，更是必然源之於這塊土地，我是「渺小」的，能過傳達「我們」認同的共通語言才是有意義的。

I have been working in design practice for nearly thirty years. In early days, I worked as in-house designer for Sampo Corporation and Robeson in New York. The rest of the time I devoted myself to my own design company simply because I enjoyed working freely in various areas. Under the influence of working as in-house designer for Sampo, my knowledge of manufacture, technology, design concept, composition and expression and product development process were cultivated. Until now the knowledge base is still influencing me. Without the base I would have suffered from more challenges in pursuing a career in design practice.

I was also influenced by the experience of solving design problems through research methods while studying at the master course at the University of Cincinnati. During this period I learned design theory and integration and application of design methodology. Additionally, the method of Quartchart which I developed at Sampo was proved to be feasible by experimental research at the University of Cincinnati. The design concept of Xun Li Kai Wu was as well better constructed at that time. All these factors made me determined to adopt rational design language and to explore deeply into the origins and intentions of things/objects.

Establishing Wen's Design Inc. in New York in 1990 was the third influence to me; at this phase I received many POP (Point of Purchase) design projects. POP can be said to be the end realization of marketing plans. Different types of products, brands, malls, subjects, material mix-and-matches and manufacturing technologies required certain standard and process. I was benefit a lot from diverse experiences that helped me working towards a wider and more practical design approaches. In the process of developing POP conceptual sketches, I gradually realized the necessity and importance of intuitive perspective drawing from eyes. Recently I have been organizing the contents of ocular measure perspective understood during this period.

In 1993, Wen's Design Inc. was officially opened and positioned itself as design service provider of product development. The company's philosophy was to follow Xun Li Kai Wu and to do business with practical attitudes. The most important goal was to assist clients in developing products that win market competitions. Sharing the joy of success with clients meant a lot to me; it also proved the existence of Wen's Design Inc. to be valuable.

In 1999, Wen's Design Inc. established its brand IDECO with the brand philosophy: quality, life and creativity. Main product lines included stationary and household products. Aluminum was the major material, and Europe was the top market. IDECO possessed over one hundred patents and its establishment and operation strengthened the company's practical experiences and won itself more European customers.

This book shows my design projects which are edited chronically, and it illustrates only part of the company's design projects. Projects not originally initiated by me are not shown in this book. Some of the projects are co-worked with other designers or craftsmen. Designers who had proposed constructive thinking in 3D construction or design process will be listed "co-designer" in the book. Craftsmen who added value to design works with skilled craftsmanship will be listed co-craftsman. I would like to give ultimate admirations to designers, clients, vendors, manufactures and institutions listed in this book, and I am greatly thankful to clients for offering me opportunities to create and design.

This book is the compilation of my design works over thirty years and I see it as a mid-term report of my life, and the chapters go on. This book also sees the contexts of the design history in Taiwan and the interactions between design and industry development. The formation of a product is an epitome of society, economy, culture and technology developments. A designer is nurtured by the land where he was born and grew. "I" am small; thus it is meaningful only to speak "our" common language.

設計理念－循理開物

　　從事設計工作多年，一直秉持著「循理開物」之理念，作為設計工作之重要依據，「循理開物」一詞，衍之於明末宋應星之著作「天工開物」，「天工」指的是自然力形成之產物（如：樹木），而利用此自然力形成之產物，再加以創造，生成之人工產物，便是「開物」（如：一張木椅）。前者指的是自然之產物，後者指的是人工之產物。「循理開物」即因循、順應著「理」，從事設計開發產物之謂，其中以「理」為引導，設計工作即近似「整理」的工作，
因此，「整理」而成「理」，「理」是一個起點，一個過程，也是一個結果，「循理開物」就是循著「整理」的途徑，達到開物的作用。

　　何謂「理」？人世間存在兩個世界，一是已知的世界，一是未知的世界。已知的世界是人類智慧所及的世界，智慧未及的世界，屬未知的世界。已知的世界，是吾人可理解的世界。而能成「理」，必然先知其「因」，「因」是成「理」之基礎，能究知其因，始有可能成「理」，自有文明以來，人世間，理無所不在。但在未知的世界，那是超越人類智慧現階段可及，不得其因的世界，無「理」可言。「循理開物」是相當入世的想法，是以人為中心，以人性為本之思維，畢竟設計之工作離開人群，即無存在的意義。

　　自然界中，存在許許多多無形、有形的力量，這些力量有其存在的既定模式及存在的「理」，任一自然界有機體的長成，必然承受與其相關之力量所影響，其中，至少有兩股不同類型的驅動力量，一種是源之於內在本質的無形力量，稱之為內力，如已知之基因，一種是影響外相的有形力量，稱之為外力，如天候、氣溫、地形等。似乎，一自然界中有機體的長成，至少同時受到無形內在與有形外相兩股力量所影

響。而內在的驅動力量往往是恆久的、是機能的，本質較貼近與生俱有的，而外相影響力量是顯性的，隨環境改變而有所差異，是較可感知的，往往是外相相互差異的展現。如此，自然界有機體的長成提供了開物的過程中，一種循理學習的途徑。

　　與自然界有機體形成最大對比的就是人為的幾何形體，自產業革命以後，為迎合機器生產，幾何形體持續被強化，直到 1920 年代構成主義以及包浩斯學院的風格發展，確立了幾何美學的基礎及價值，1950 年代的極簡藝術更是將幾何美學推到了極致，幾何形體雖非一生命體，但必然經過人為創意所形成，人為創意亦具備內力與外力兩股推動力量，內力是創意的根源、本質及出發點，外力是形成的手段、技術及技藝，天工或開物均受其內力及外力所影響，「理」是開物途徑的一種動態的循環，涉及了內力與外力的兩股力量，「理」存在於人世間已知的世界，不僅包括自然之「理」，亦擴及到人為之「理」，凡事只要能知其因，就有可能成「理」，即能為開物途徑所用，有「理」未必能走遍天下，但離事實真相之探究已經不遠。

　　凡一設計物件在孕育成形之初，必然依據客觀者相當之思維及合理規劃之標的，雖在成形之初是模糊、不確定的狀態，但隨著內力的驅動及外力的影響而逐漸成形，也就是說，一設計物件在成形之初，其本質即已存在，創作途徑是依循著「理」為依據，循序漸進而整「理」，最後呈現「理」的面相及語言。以人為中心是「理」的出發點，是一種內力、是一種善念，「理」的過程是以最大客觀的可能尋求真相，是一種外力、一種科學，最後呈現的面相是一種理性的美感，是一種藝術。相關的概念請參閱下一頁圖示。

反映在我個人實務的設計過程，任一環節均訴求合「理」，從內在機能的合「理」詮釋到外向的合「理」展現，以及與外界環境之關係合「理」建立，如未能究知其因，未能道出其理，一概保留或捨棄不用，這是基本堅持的態度。在其他實務層面，任一環節尋求合「理」之態度，亦是一致：相關設計的原意，機能的完整、適切的造形、生產的簡易、材質的應用等等諸多層面的問題，錯綜複雜，如何在最大客觀的可能性之中兼顧、妥協而完整的呈現，這是「整理」的過程，一種理性的設計語言似乎是必然的呈現。設計過程中，每一步驟，都是「整理」的動作，即使是「整理」細微的角落，所為之「因」的理解是重要的，如能道出且認知所為為何之時，自然成「理」。

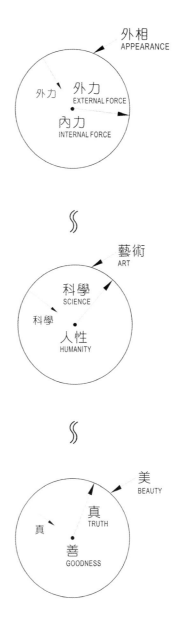

成形之初使，物件之本質即已存在，依循整「理」之途徑，將之實現

「理」的本體：開物的途徑
「理」是起點：是過程，也是結果
「理」是一個循環

Design Philosophy –
Xun Li Kai Wu (Follow essential of facts, create objects)

For many years, I have been holding the spirit of Xun Li Kai Wu (Follow essential of facts, create objects) as an important basis of my design practice. The term Xun Li Kai Wu is derived from Song Ying-Shin's book Tien Gong Kai Wu (also known as Ancient Chinese Technology) written in the late Ming dynasty in the 17th century. Tien Gong refers to natural creatures, such as trees. Kai Wu refers to objects made out of natural creatures by humans, for example, a chair. The former is natural creature, and the later is man-made object. Thus Xun Li Kai Wu means to following Li (essential of facts) to create Wu (objects), which literally refers to design and production process, are guided by Li. Design activity is similar to Zheng Li. ("Zheng", "Li" and "Zheng Li" all bear the meaning "to organize or organization"). Li (essential of facts) is starting point, process, and outcome. Xun Li Kai Wu means following the path of Zheng Li to reach the end result - Kai Wu.

What is Li? There exist two worlds: one is the already-known, the other is the unknown. The already-known world can be understood by we human beings, and the opposite is the unknown world. Cause is the basis of Li. Only if we explore and understand the causes, there will be chances to create Li. Li is ubiquitous in our world ever since human civilization. There is no causes in the unknown world, resulting in the absence of Li. Xun Li Kai Wu is people-centered thinking based on humanity. Without people design activity is meaningless.

In nature, there are many invisible and visible forces that inevitably have their reasons and modules of existence. The growth of any natural organism is sustained and influenced by its related forces. Among them, there are at least two different types of driving forces are indentified. One is the invisible internal force originated from intrinsic quality, such as gene. The other is physical force that affects the appearances, such as weather, temperature and landforms. It seems that the growth of natural organism is simultaneously influenced at least by both the invisible internal and physical external forces. The internal driving force is eternal and functional, and its essence is inherent. The external force that affects appearance is dominant and recognizable; it changes along with environment and it is the presence of different appearances. Accordingly, the growth of natural organism provides a path of learning Xun Li Kai Wu.

The biggest contrast to natural organism is man-made geometric forms. Since the industrial revolution, geometric forms were continuously reinforced. Until 1920s the births of Constructivism and Bauhaus styles defined the values and foundations of geometric aesthetics. In 1950s, geometric aesthetics was peaked due to Minimalism. Geometric forms are not living body but there formations must be conducted through human creativity. Internal and external forces are also included in human creativity; the former is the origin, substance and starting point of creativity and the later is the means, skills and technology of formation. Tien Gong or Kai Wu both are influenced by internal and external forces. Li involves with the both forces. Li is the dynamic cycle of the development of objects. Li exists in the world already known by human beings. Li refers not only to natural reason but also to the man-made rationality. Li is inherited in anything as long as we explore deeply into the causes and reasons, then anything can be followed by Xun Li Kai Wu. Having every reason may not be able to trot the globe; however, it may be close to the exploration of truth.

A design object is vague and unclear in its infancy and it must be developed according to subjective thoughts and rational planning. Gradually a design object is shaped along with the inner driving force and external influences. In other words, the substance already exists before the shaping of a design object. Creation paths follow and stand on Li. Through Zheng Li(organize), appearance and language of Li will be embodied and presented in the end. The starting point of Li is human center. Li is a kind of inner force and goodness. The making of Li is to search for truth with the most objective possibility. In this case, Li is a kind of external force and science, and the end appearance is rational aesthetics and art. The related concepts are explained in the diagrams.

Reflected in my design practices that every step has to be in accordance with Li (essential of facts), from "reasonable"

interpretation of inner function to "reasonable" presentation of appearance and "reasonable" establishment of relationship with the outer world. I insist to suspend or abandon ideas if their causes and reasons are not being understood. This is my attitude. I also keep the same attitude in other practices. Factors such as the original meaning of design, completion of functions, moderate forms, efficiency of production and applications of material are complicated and interrelated with each others. How to give consideration to all these factors and make compromised yet completed presence is the process of Zheng Li (organize). In the end a universal design language seems to be an expected result. In design process every step is the activity of Zheng Li (organize), even if it is the organization of tiny subtle matters. Understanding cause and reason is important. Li can be naturally formed if one understand and recognize what Li is.

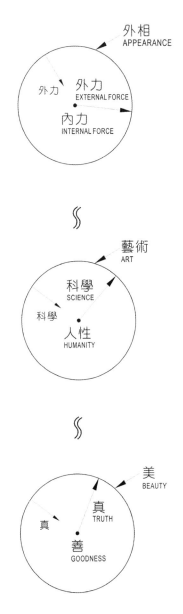

AT THE TRUE BEGINNING, EVERY OBJECT HAS
ITS NATURE TO FOLLOW.

THE SUBSTANCE OF 「LI」: THE PATH TO KAI-WU.
「LI」 IS STARTING POINT, PROCESS, AND OUTCOME AS WELL.
「LI」 IS A CYCLE.

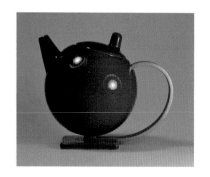

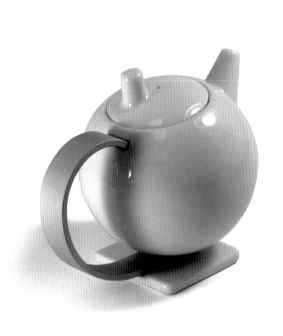

PITCHER
CERAMICS W/ AL HANDLE
CO-DESIGNER: YI-HSUAN LIU
2011
PATENT BY T&T

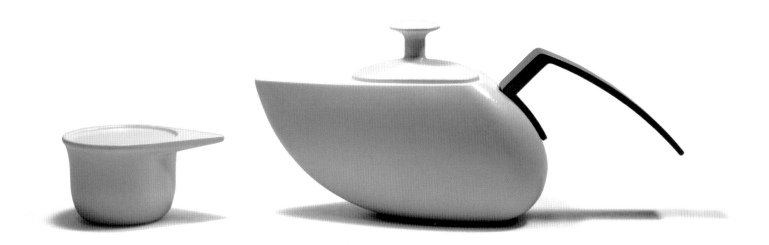

PITCHER
CERAMICS W/ AL HANDLE
2011
PATENT BY T&T

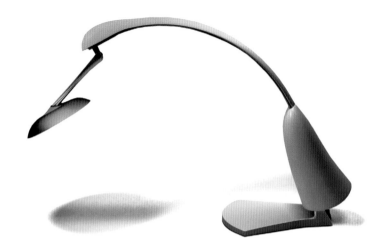

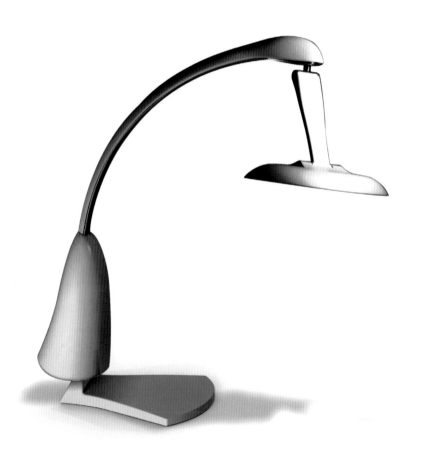

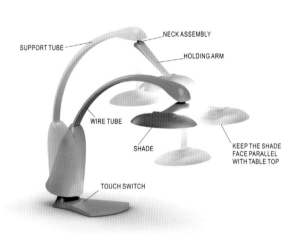

SUPPORT TUBE
NECK ASSEMBLY
HOLDING ARM
WIRE TUBE
SHADE
KEEP THE SHADE FACE PARALLEL WITH TABLE TOP
TOUCH SWITCH

LED TABLE LAMP (GOO-LIT)
ACRYLIC, ABS, AL, ZINC ALLOY, ETC.
2011
PATENT BY FOURSOME GLOBAL

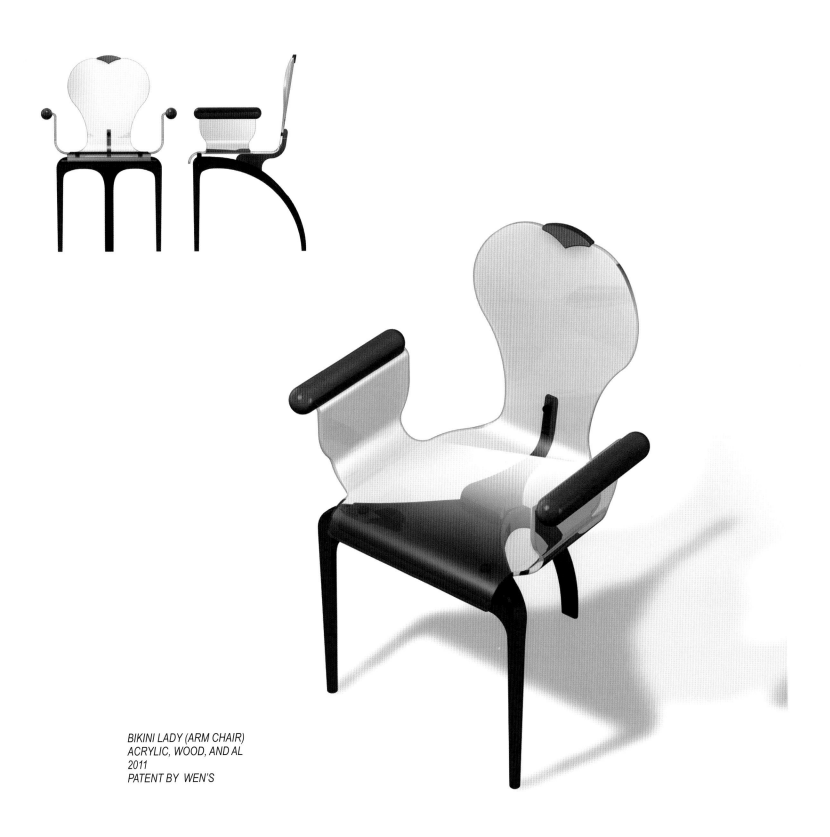

BIKINI LADY (ARM CHAIR)
ACRYLIC, WOOD, AND AL
2011
PATENT BY WEN'S

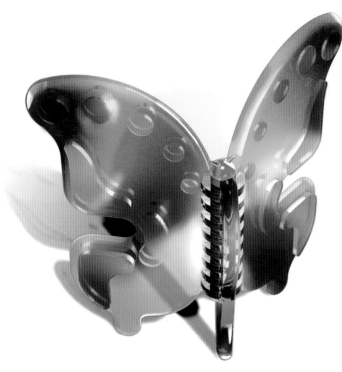

LED LIGHTING (BUTTERFLY 1)
ACRYLIC, GLASS, AL, ETC.
2011
PATENT BY WEN'S

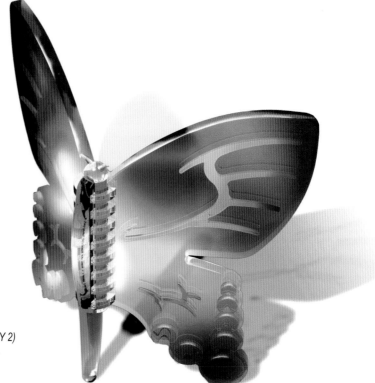

LED LIGHTING (BUTTERFLY 2)
ACRYLIC, GLASS, AL, ETC.
2011
PATENT BY WEN'S

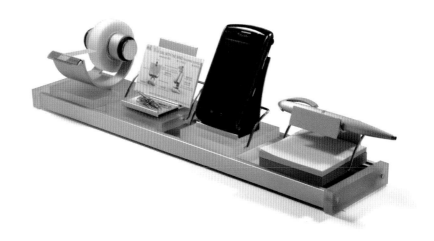

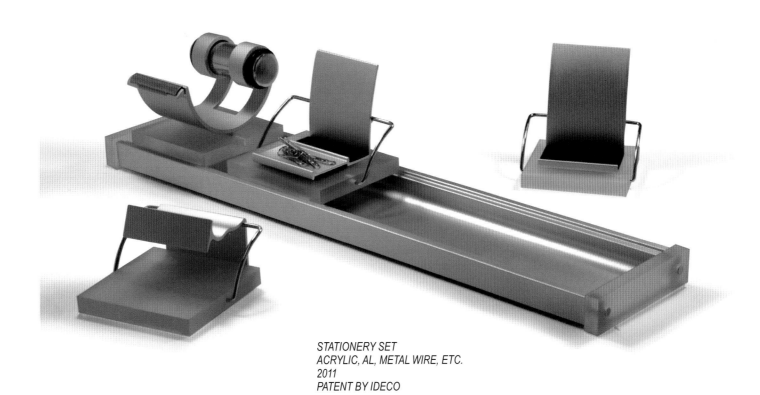

STATIONERY SET
ACRYLIC, AL, METAL WIRE, ETC.
2011
PATENT BY IDECO

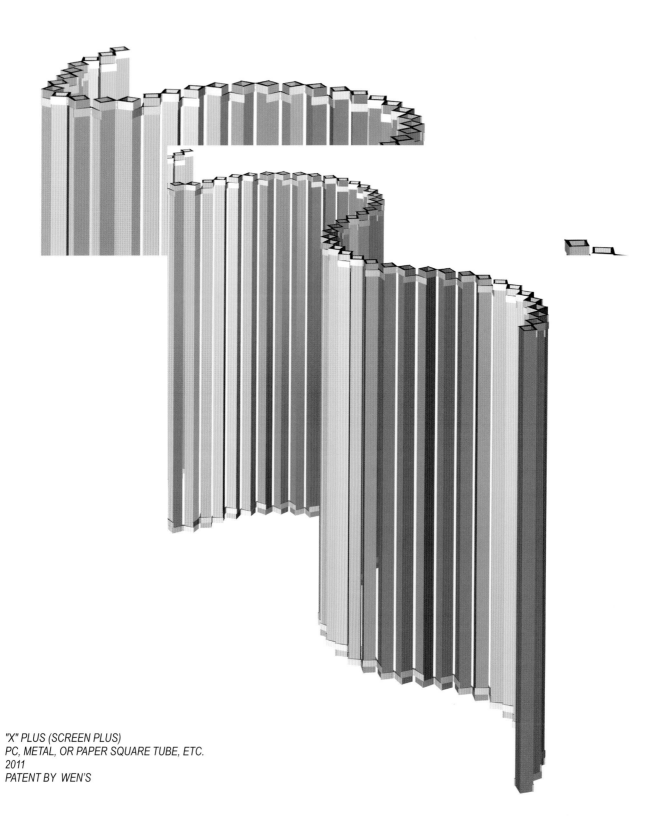

"X" PLUS (SCREEN PLUS)
PC, METAL, OR PAPER SQUARE TUBE, ETC.
2011
PATENT BY WEN'S

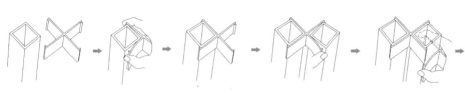

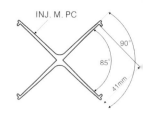

INJ. M. PC

90
85°
41mm

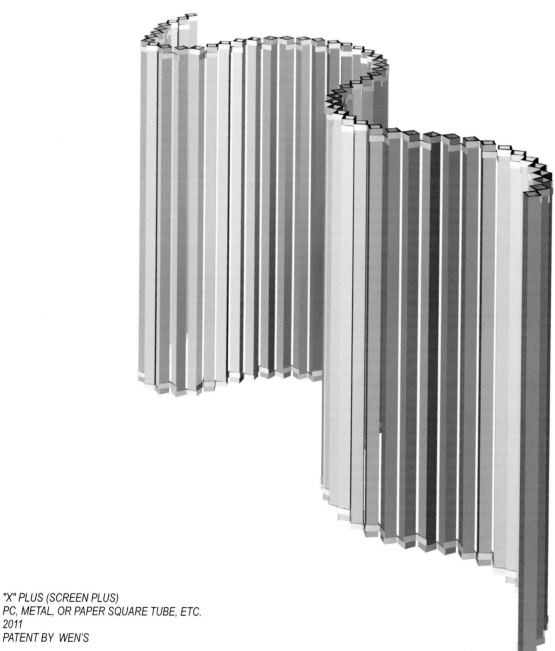

"X" PLUS (SCREEN PLUS)
PC, METAL, OR PAPER SQUARE TUBE, ETC.
2011
PATENT BY WEN'S

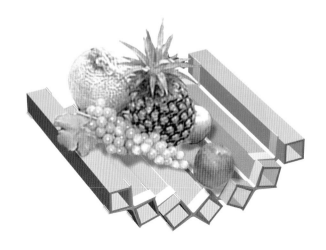

FRUITS HOLDER

WINE HOLDER

MAGAZINE RACK

GABBAGE BIN

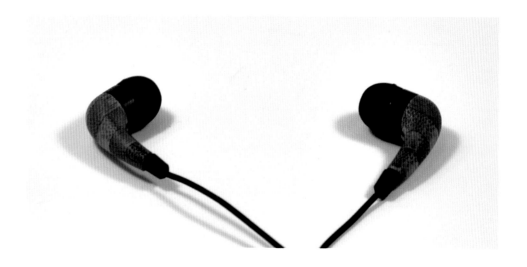

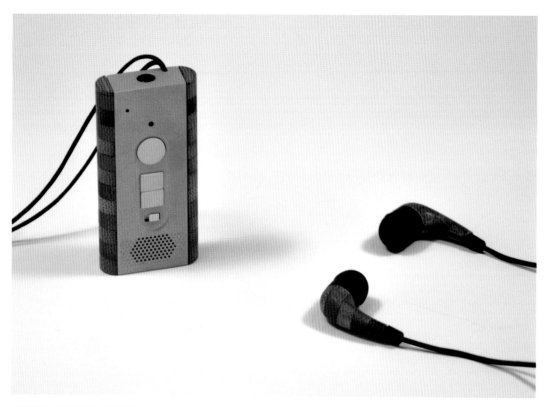

MINI PHONE (BLUE TOOTH)
BAMBOO, AL, ABS, ETC.
2011
PATENT BY WEN'S

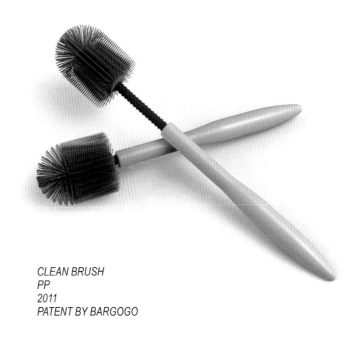

CLEAN BRUSH
PP
2011
PATENT BY BARGOGO

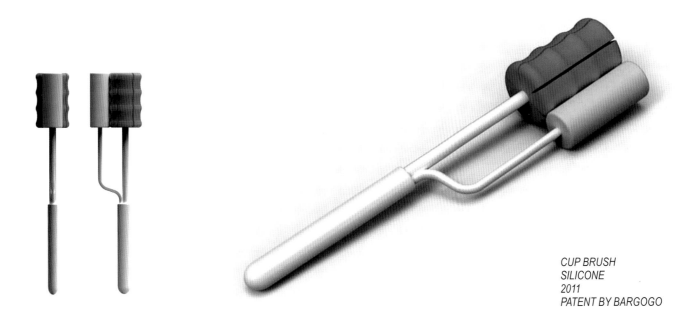

CUP BRUSH
SILICONE
2011
PATENT BY BARGOGO

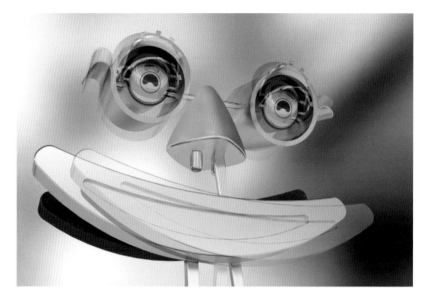

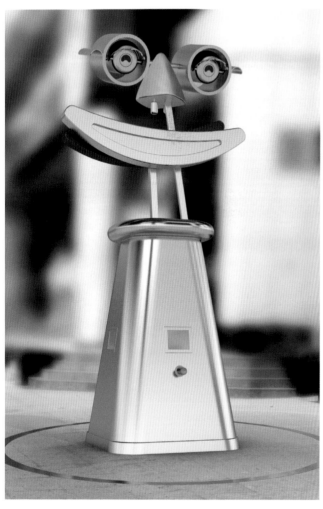

SMILING AT PUBLIC
STAINLESS STEEL
2011
PATENT BY WEN'S

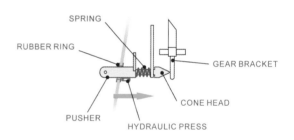

SPRING

RUBBER RING

GEAR BRACKET

CONE HEAD

PUSHER

HYDRAULIC PRESS

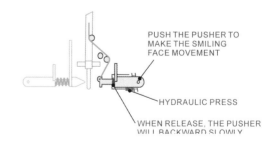

PUSH THE PUSHER TO
MAKE THE SMILING
FACE MOVEMENT

HYDRAULIC PRESS

WHEN RELEASE, THE PUSHER
WILL BACKWARD SLOWLY

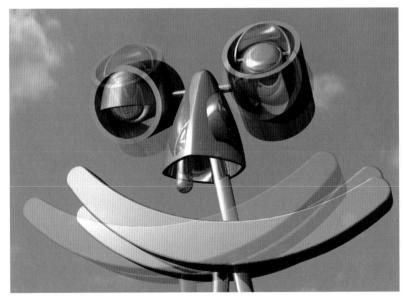

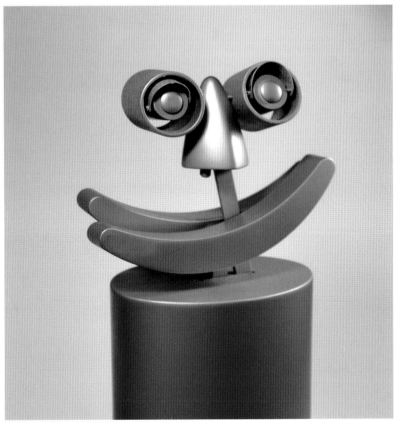

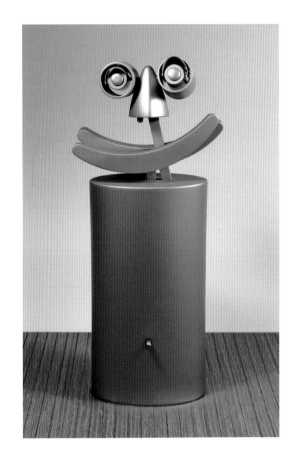

SMILING ON THE TABLE
ABS, STEEL, RUBBER, ETC.
2011
PATENT BY WEN'S

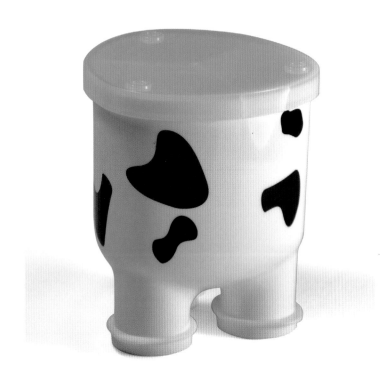

MILK POWDER CASE
PC
2011
PATENT BY BASILIC

CORNER PROTECTOR
SILICONE
2011
PATENT BY BASILIC

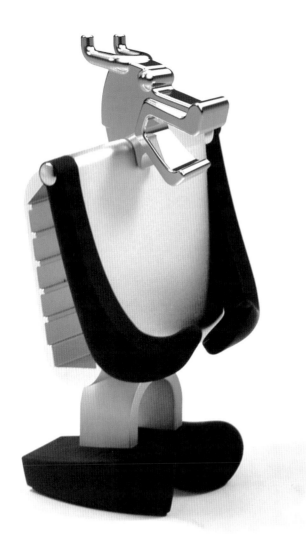

DRAGON FIGURINE
ABS ,AL, ZINC ALLOY, ETC.
2011
PATENT BY WEN'S

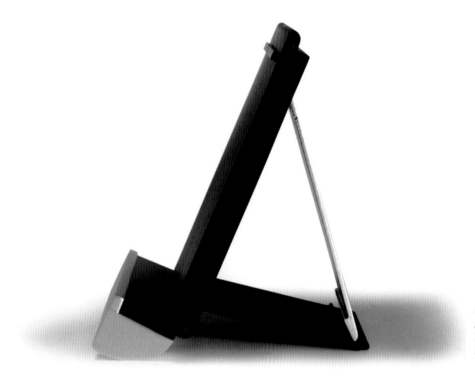

STAND FOR IPAD(3)
ABS, RUBBER, & AL
2011
PATENT BY IDECO

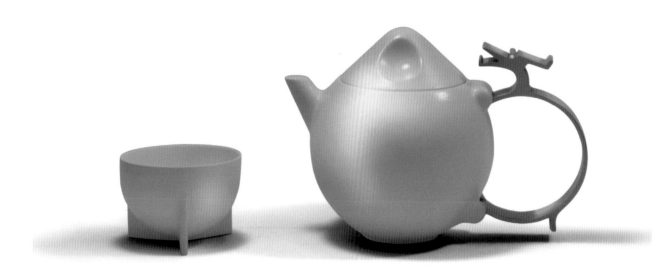

PITCHER
CERAMICS W/ AL HANDLE
CO-DESIGNER: I-SHINE LIU
2011
PATENT BY T&T

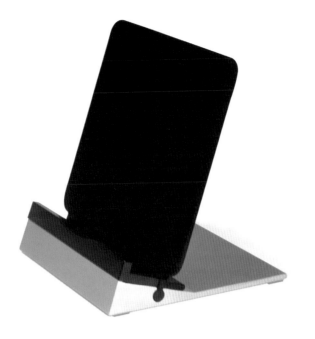

STAND FOR IPAD(1)
ABS, RUBBER, & AL
2011
PATENT BY IDECO

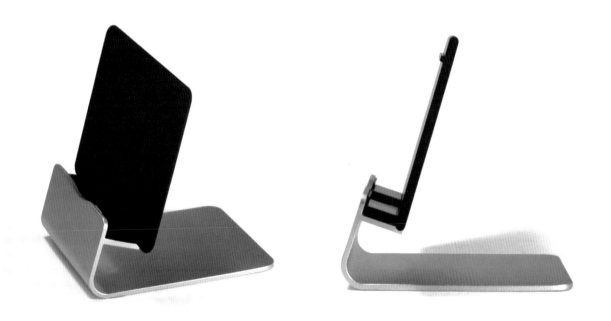

STAND FOR IPAD(2)
ABS, RUBBER, & AL
2011
PATENT BY IDECO

STATIONERY SET
LEATHER, AL, ABS, ETC.
2011
PATENT BY IDECO

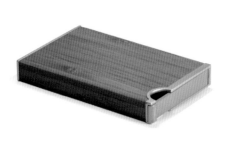

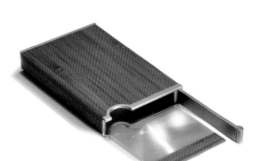

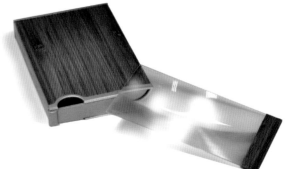

NAME CARD BOX
AL, BAMBOO, ETC.
2011
PATENT BY WEN'S

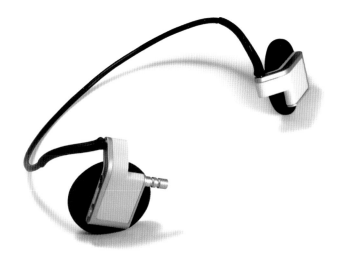

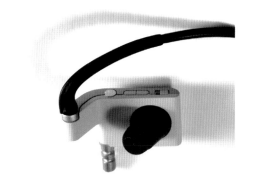

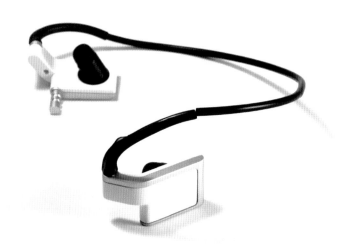

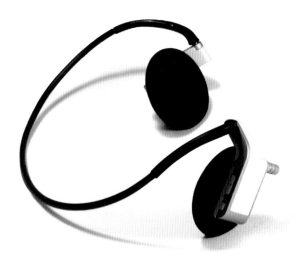

BLUE TOOTH EARPHONE
AL, ABS, ETC.
2011
PATENT BY HI-PRO

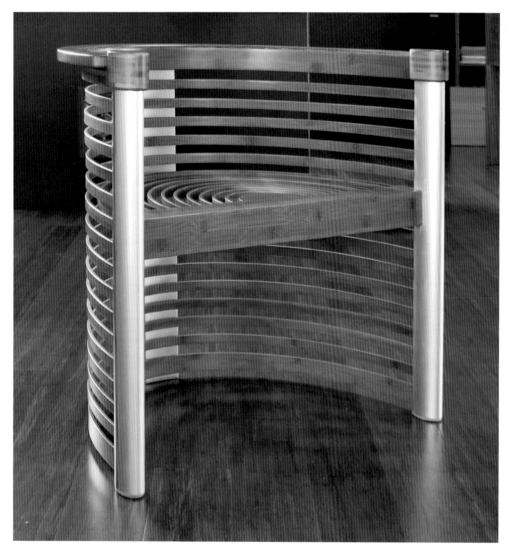

ARM CHAIR
BAMBOO & AL
CO-CRAFTSMAN: WEN-FANG LIU
2011
PATENT BY NTCRDI

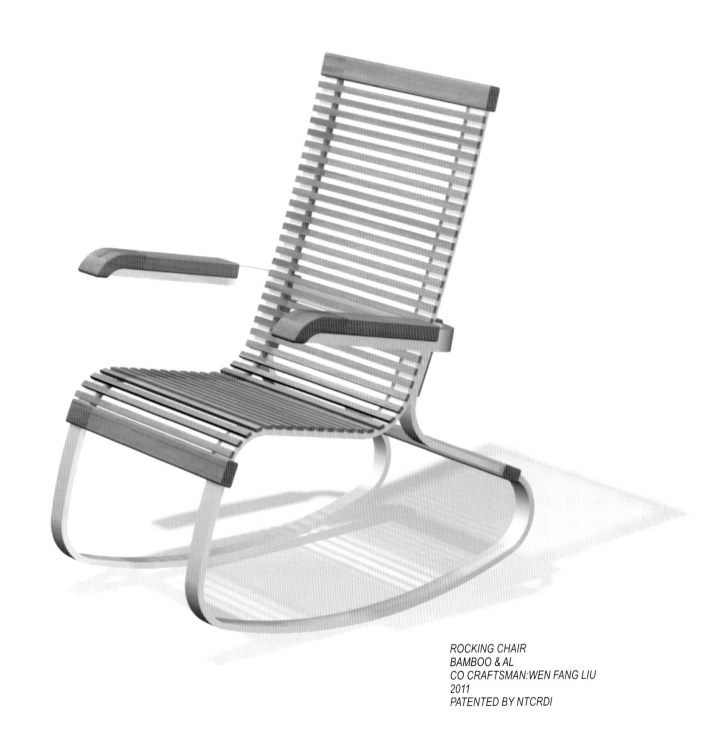

ROCKING CHAIR
BAMBOO & AL
CO CRAFTSMAN:WEN FANG LIU
2011
PATENTED BY NTCRDI

JEWERLY BOX
LACQUERED AL & ABS
CO CRAFTSMAN: SU-FA WU
2010
PATENT BY NTCRDI

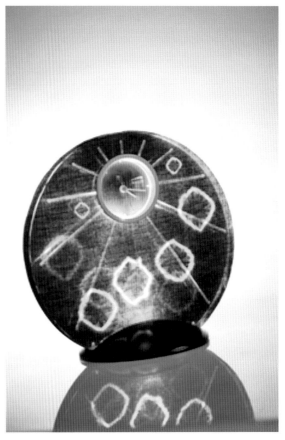

LED LIGHTING + CLOCK
BLUE DYE, AL, ABS, ETC.
CO-CRAFTSMAN: WEN-JING TUNG
2010
PATENT BY NTCRDI

MEDICINE BOX
BAMBOO, AL, ABS, ETC.
CO-CRAFTSMAN: WEN-FANG LIU
2010
PATENT BY NTCRDI

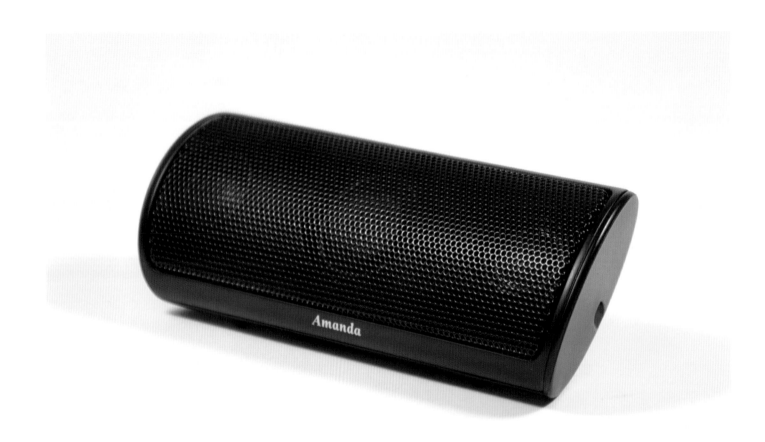

USB SPEAKER
ABS, CHROME, METAL MUSH, ETC.
2010
PATENTED BY PROSONIC

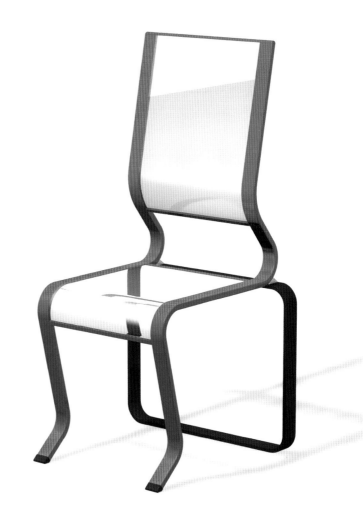

SEAT ON SEAT
ACRYLIC, AND AL
2010
PATENT BY WEN'S

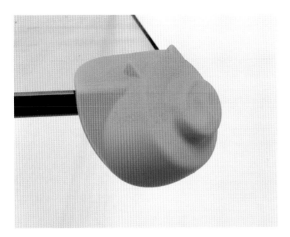

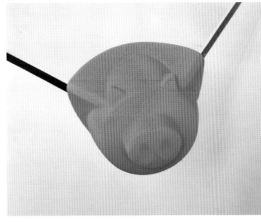

CORNER PROTECTOR
SILICONE
2011
PATENT BY BASILIC

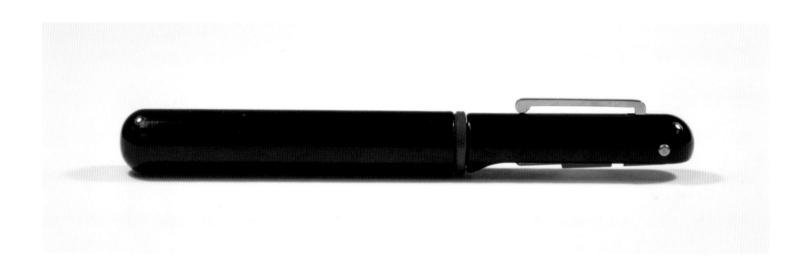

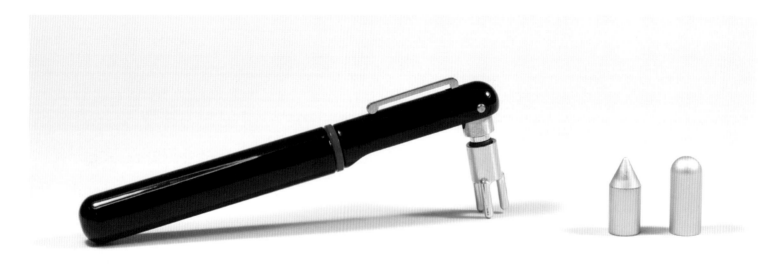

KNOCK ANYTIME(MASSAGE PEN)
LACQUERED BRASS, STEEL, AL., ETC.
CO-CRAFTS'MAN: SU-FA,WU
2010
PATENT BY NTCRDI

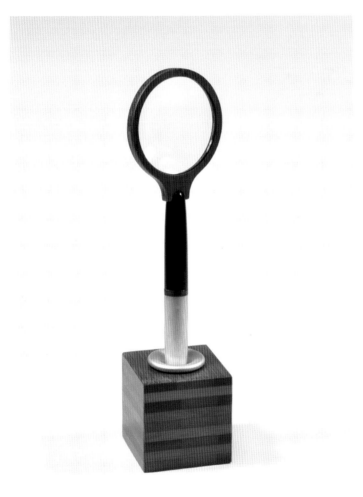

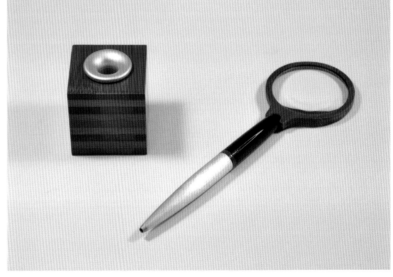

PEN W/ MAGNIFIER
BAMBOO, LACQUER, AL, ETC.
CO-CRAFTSMAN: WEN-FANG LIU, SU-FA WU
2010
PATENTED BY NTCRDI

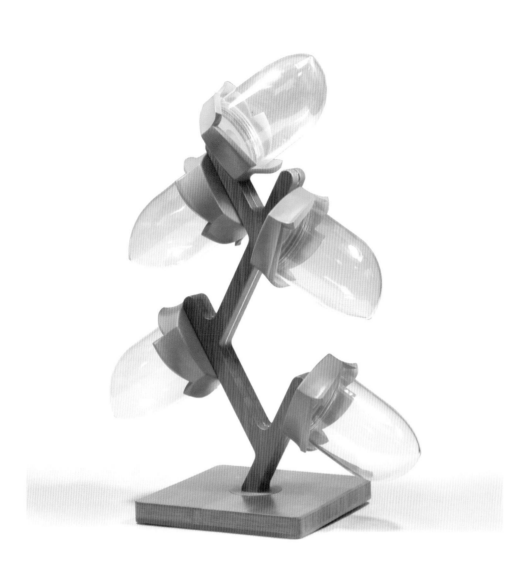

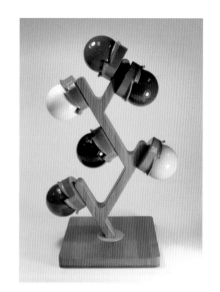

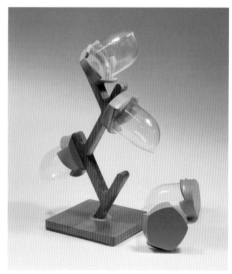

CANISTER
BANBOO, STEEL, ABS, PC, ETC.
CO-CRAFTSMAN: WEN-FANG LIU
2010
PATENT BY NTCRDI

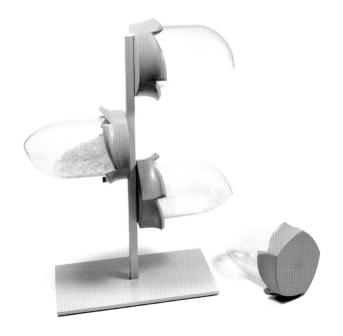

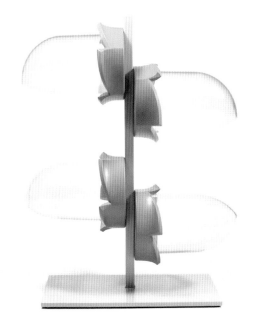

CANISTER
STEEL, ABS, AND PC
2010
PATENT BY WEN'S

RECYCLE STORY

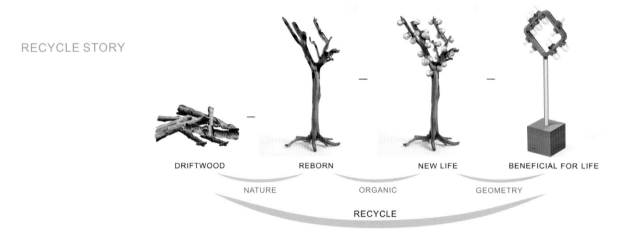

DRIFTWOOD — REBORN — NEW LIFE — BENEFICIAL FOR LIFE

NATURE ORGANIC GEOMETRY

RECYCLE

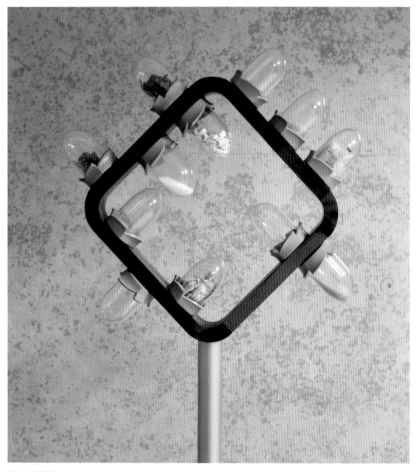

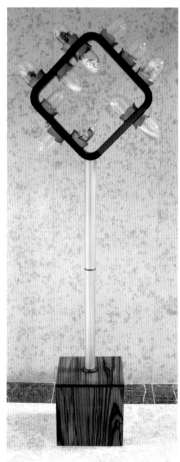

CANISTER
DRIFTWOOD, STEEL, ABS, AND PC
CO-CRAFTSMAN: MAU-FAUNG CHANG
2010
PATENT BY WEN'S

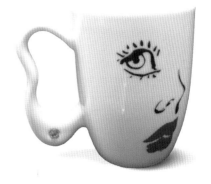

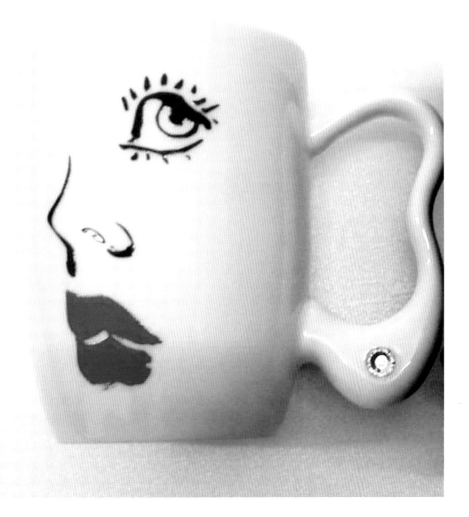

CUP
CERAMIC W/ DIAMOND CRYSTAL
CO-DESIGNER: YEE-SHIN CHAY
2010
PATENT BY BARGOGO

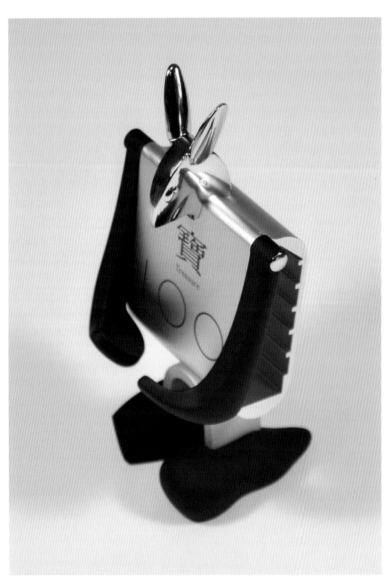

A-BAO (PEN & CARD HOLDER)
ABS, AL, METAL CHROME, ZINC ALLOY, ETC.
2010
PATENT BY WEN'S

STATIONERY BOX
LACQUERED & AL
CO-CRAFTSMAN: SU-FA WU
2010
PATENT BY NTCRDI

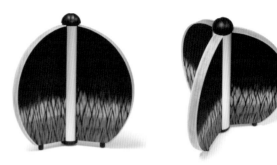

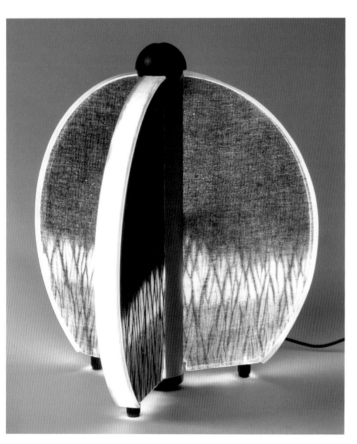

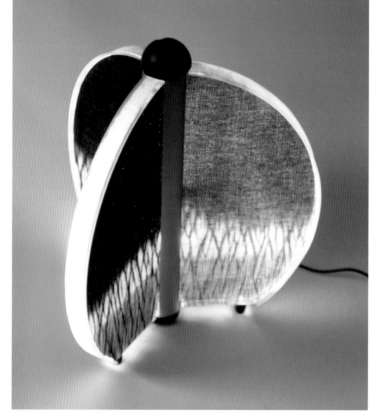

LED LIGHTING
BLUE DYE & AL
CO-CRAFTSMAN: WEN-JING TUNG
2010
PATENT BY NTCRDI

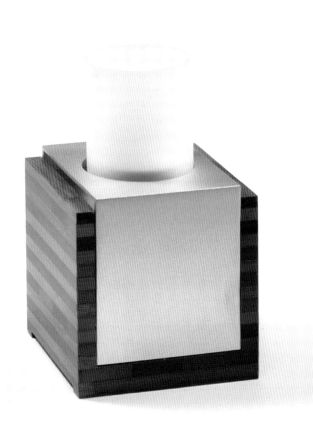
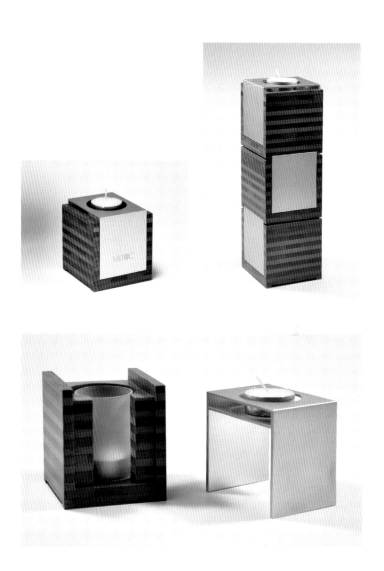

CANDLE STAND
BAMBOO & AL
CO-CRAFTSMAN: WEN-FANG LIU
2010
PATENT BY NTCRDI

33

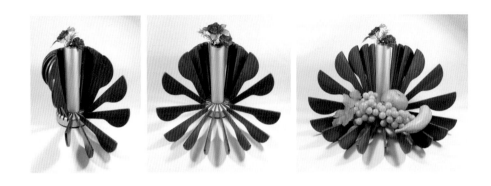

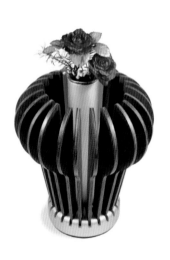

VASE & FRUIT TRAY
WOOD, AL, GLASS, ETC.
2010
PATENT BY NTCRDI

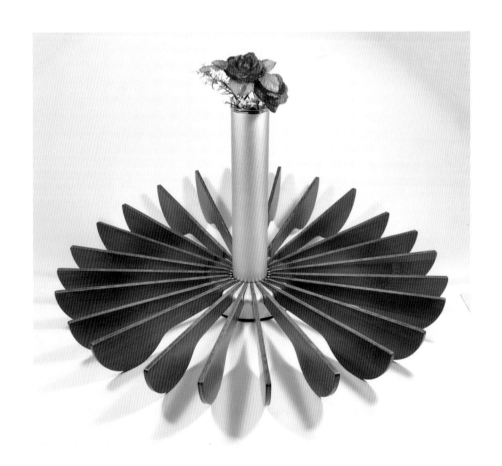

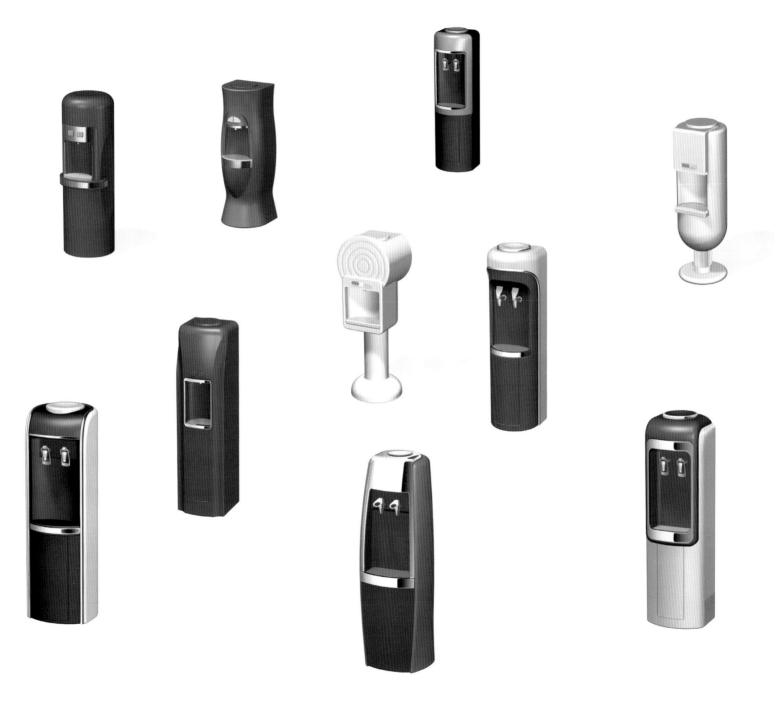

COOLER
PP, CHROME, ABS, ETC.
CO-DESIGNER: MIN-LIU SHIEH
2010
PATENT BY PROSONIC

SALT RIMMER W/FRUIT BOX
ABS, PC, PP, ETC.
2009
PATENT BY WORLD LINK

SALT RIMMER W/ FRUIT BOX
ABS, PC, PP, ETC.
2009
PATENT BY WORLD LINK

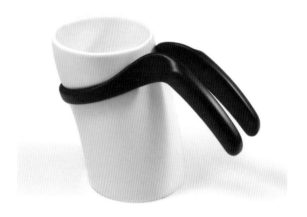

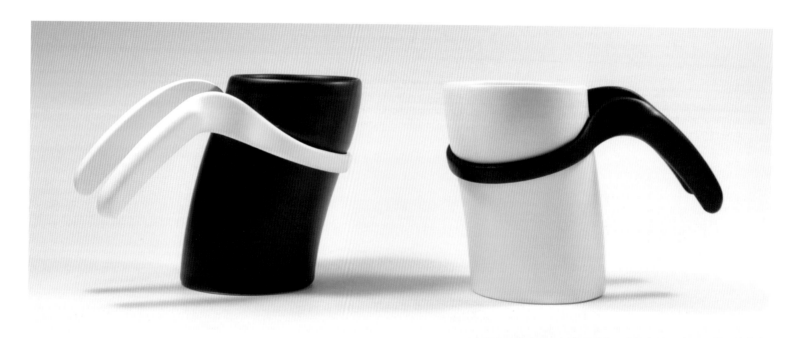

WINGS OF ANGEL(CUP)
PC & CERAMIC
2009
PATENT BY NTCRDI

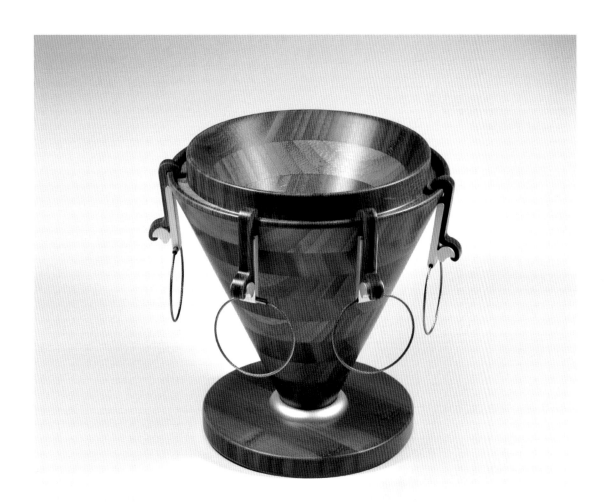

MONKEY TREE
AL, BAMBOO, STEEL WIRE, ETC.
2009
PATENT BY NTCRDI

CLEAN LIFT STATIONERY SET
ABS, AL, CHROME METAL, ETC.
2009
PATENT BY IDECO

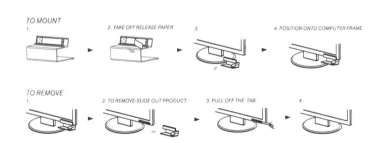

TO MOUNT
1.
2. TAKE OFF RELEASE PAPER.
3.
4. POSITION ONTO COMPUTER FRAME.

TO REMOVE
1.
2. TO REMOVE-SLIDE OUT PRODUCT.
3. PULL OFF THE TAB.
4.

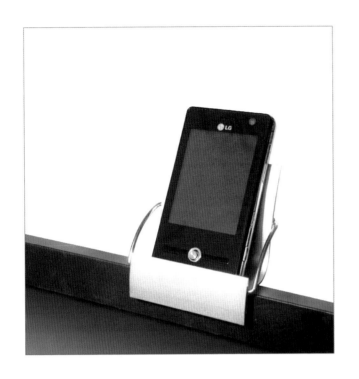

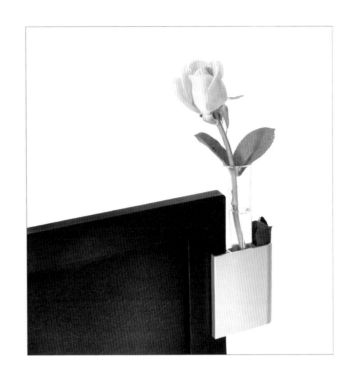

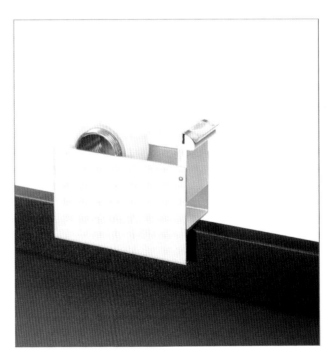

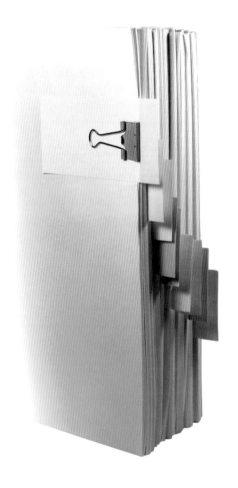

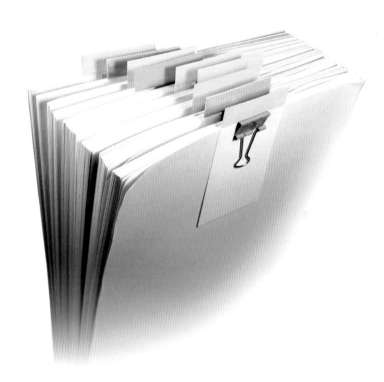

CLIP-DEX
PAPER
2009
PATENT BY IDECO

LUCKY BOX
LACQUERED PLASTIC, WOOD, AL ETC.
2009
PATENT BY WEN'S

PAPER CLIP HOLDER (GREED DRAGON)
BAMBOO, ACRYLIC, AL, ETC.
2009
PATENT BY WEN'S

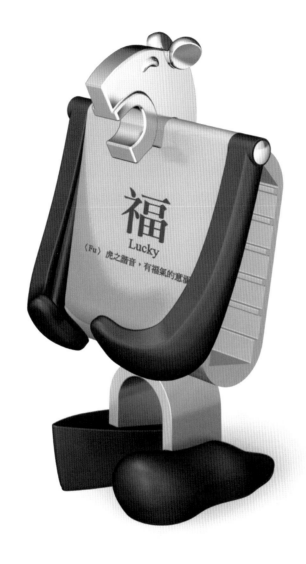

福
Lucky

〈Fu〉虎之諧音，有福氣的意涵

TIGER FIGURINE
ABS, AL, ZING ALLOY, ETC.
2009
PATENT BY WEN'S

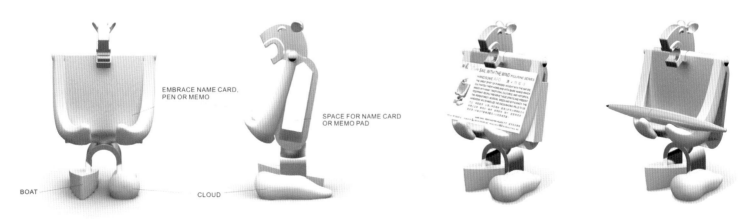

EMBRACE NAME CARD.
PEN OR MEMO

SPACE FOR NAME CARD
OR MEMO PAD

BOAT

CLOUD

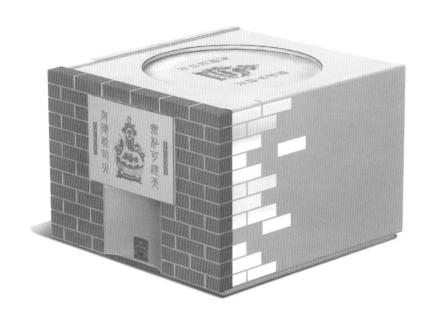

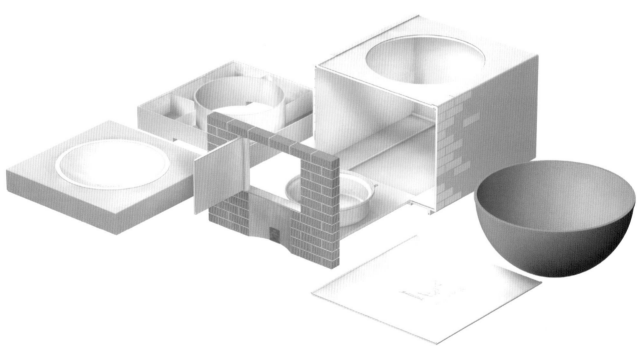

PORTABLE STOVE
AL, STELL, ABS, ETC.
2008
PATENT BY WEN'S

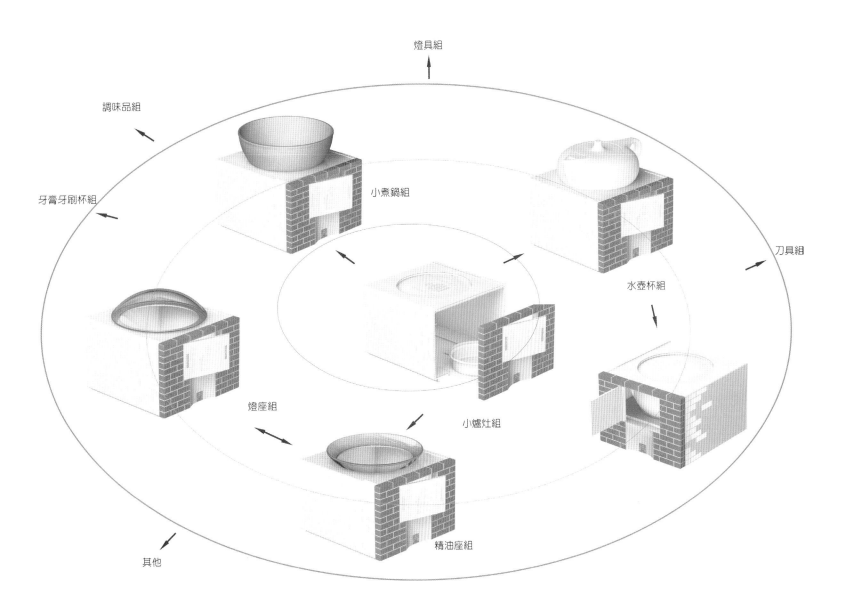

燈具組

調味品組

牙膏牙刷杯組

小煮鍋組

刀具組

水壺杯組

燈座組

小爐灶組

其他

精油座組

47

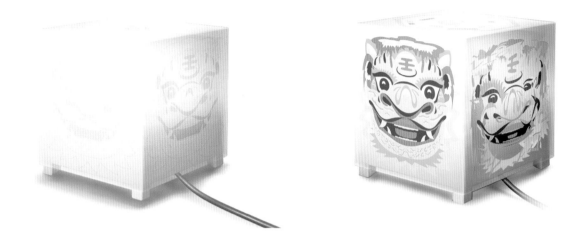

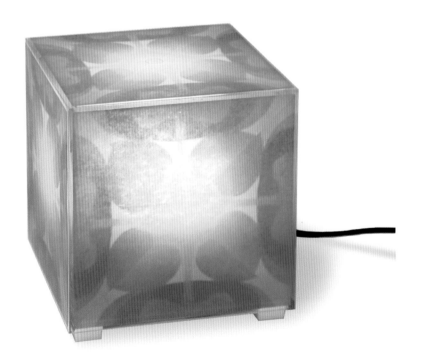

CUBIC LED LIGHTING
PP, ABS, ACRYLIC, ETC.
2008
PATENT BY NTTA

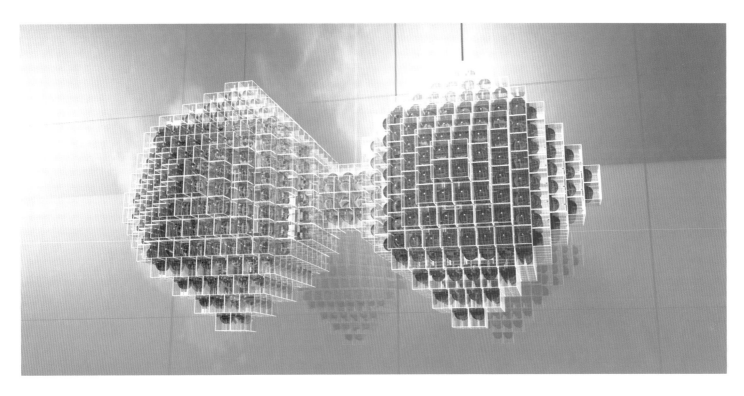

CUBIC LED LIGHTING (LED LIGHTING)
PP, ABS, ACRYLIC,STEEL, ETC.
2008
PATENT BY WEN'S

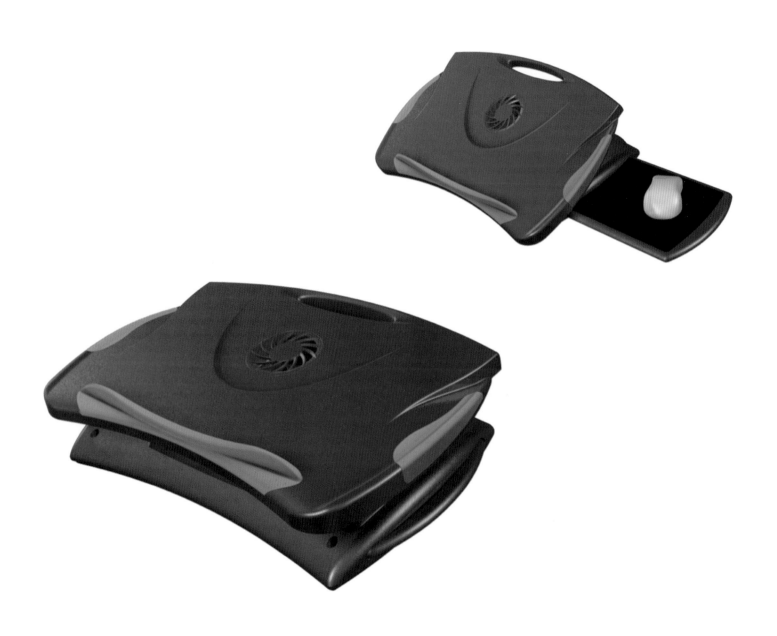

NB STAND
ABS, RUBBER, SPONGE, ETC.
2008
PATENT BY AIDATA

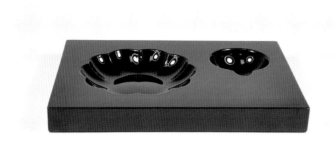
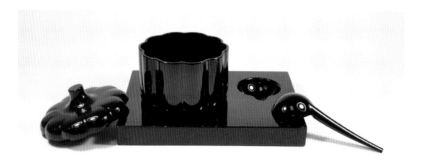

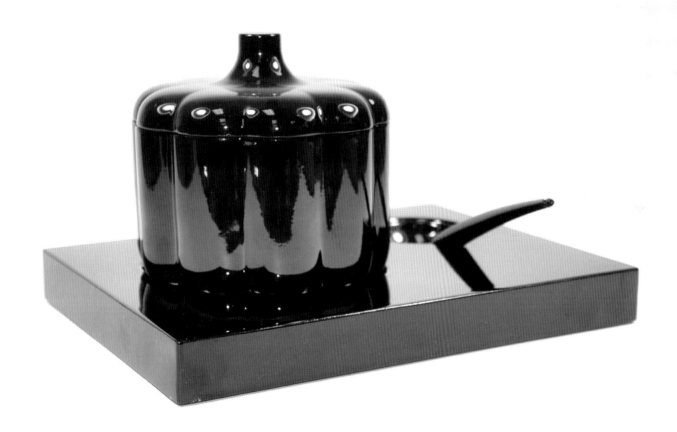

PUMPKIN SOUP BOWL
LACQUER
CO-CRAFTSMAN: SU-FANG WU
2008
PATENT BY NTCRDI

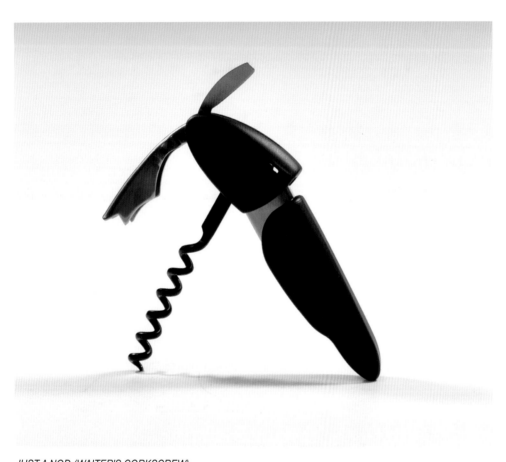

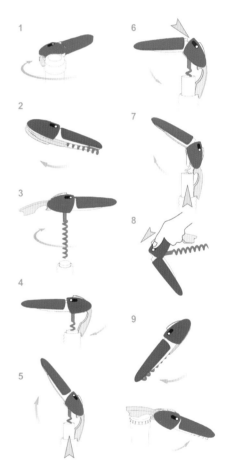

JUST A NOD (WAITER'S CORKSCREW)
INJ. M. ABS, STAINLESS STEEL
2008
PATENT BY WORLD LINK

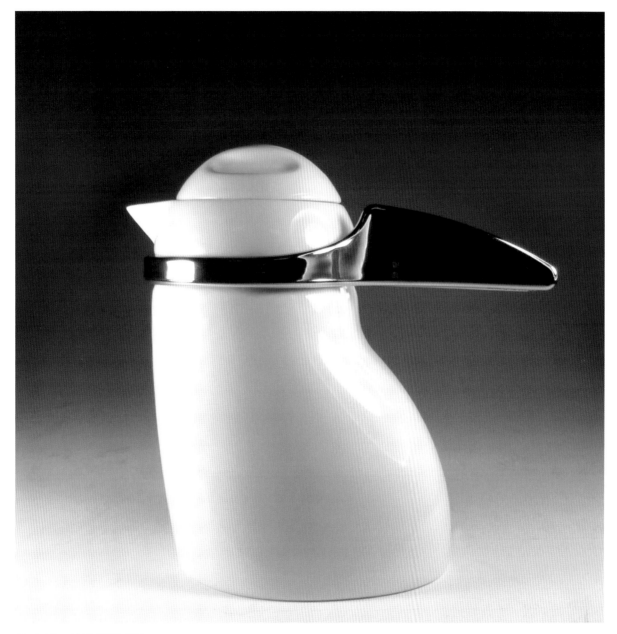

CHICKEN ANGEL (PITCHER)
CERAMIC & PC
2008
PATENT BY WEN'S

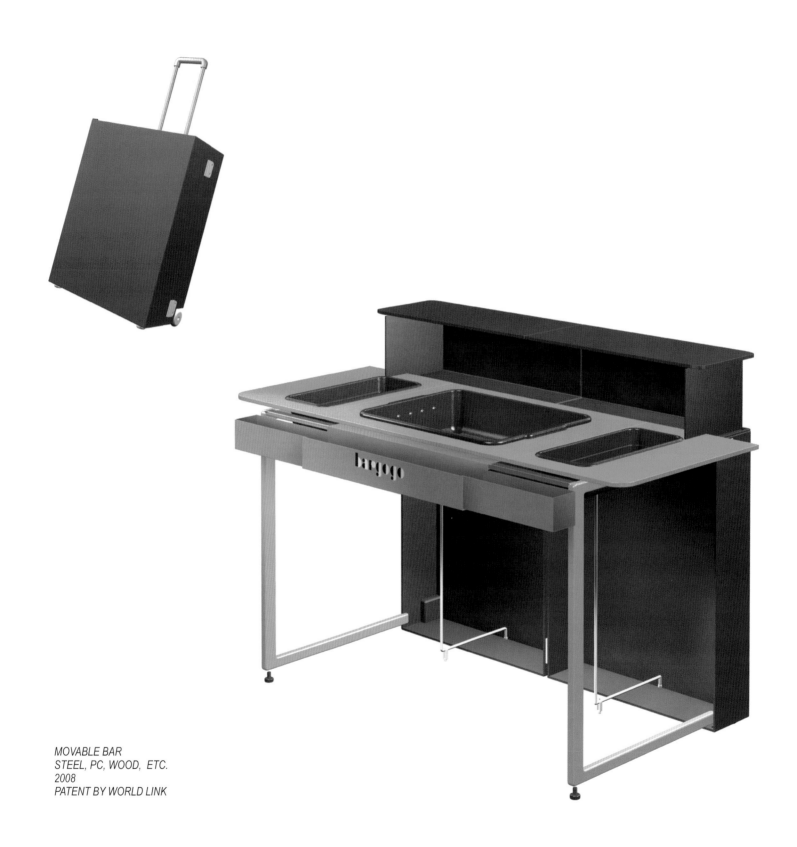

MOVABLE BAR
STEEL, PC, WOOD, ETC.
2008
PATENT BY WORLD LINK

FRUIT TRAY
METAL WIRE & SILICON CLOTH
2008-2009
PATENT BY WEN'S

CUTTING BOARD
PP
2008
PATENT BY BARGOGO

FRUIT CUTTER
STEEL, PC, ABS, ETC.
2008
PATENT BY WORLD LINK

POS
AL, ABS, PC, RUBBER, STEEL, ETC.
2007
PATENT BY FEC

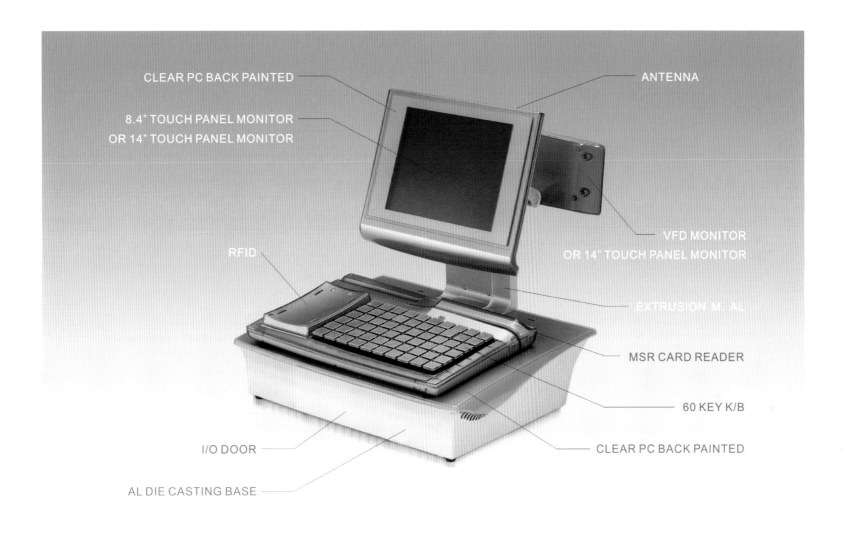

CLEAR PC BACK PAINTED

ANTENNA

8.4" TOUCH PANEL MONITOR
OR 14" TOUCH PANEL MONITOR

VFD MONITOR
OR 14" TOUCH PANEL MONITOR

RFID

EXTRUSION M. AL

MSR CARD READER

60 KEY K/B

I/O DOOR

CLEAR PC BACK PAINTED

AL DIE CASTING BASE

ROSE VASE
ACRYLIC
2007
PATENT BY NTTA

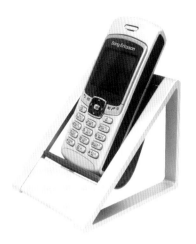

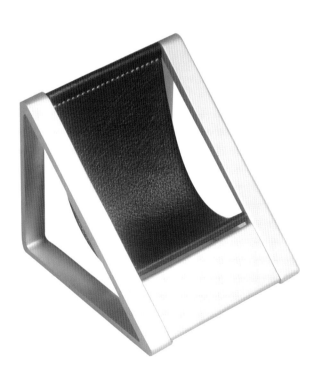

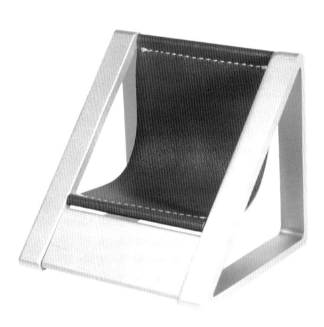

MOBILE HOLDER
AL, STEEL, LEATHER, ETC.
2007
PATENT BY IDECO

LED STREET LIGHTING
AL, STEEL, RUBBER, ETC.
2007
PATENT BY A-HA

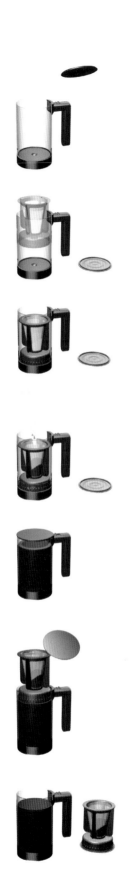

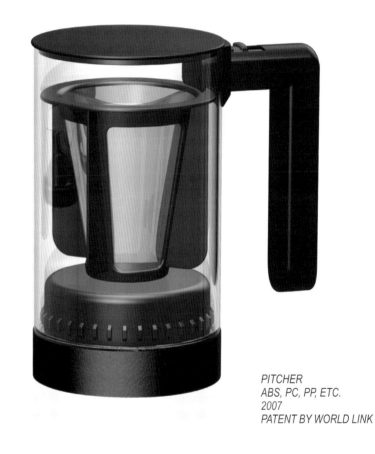

PITCHER
ABS, PC, PP, ETC.
2007
PATENT BY WORLD LINK

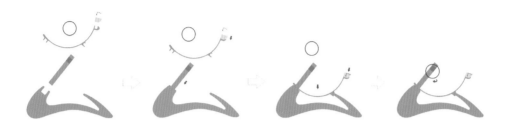

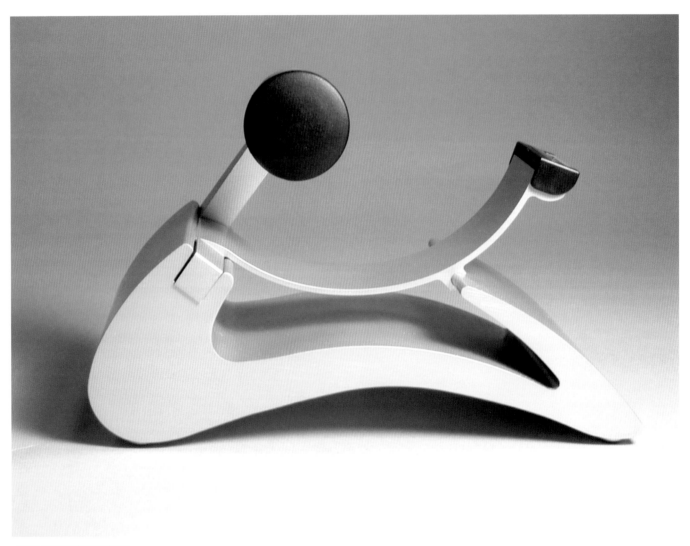

JUMP (TAPE DISPENSER)
AL, ABS, STEEL, ETC.
2007
PATENT BY WEN'S

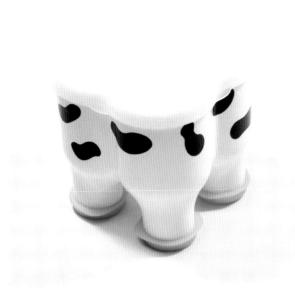

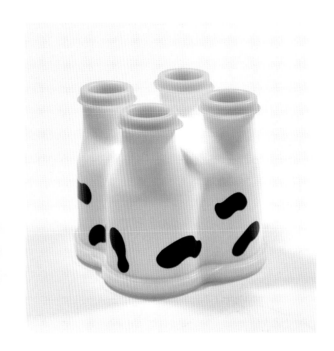

MILK POWER CASE
PC
2008
PATENT BY BASILIC

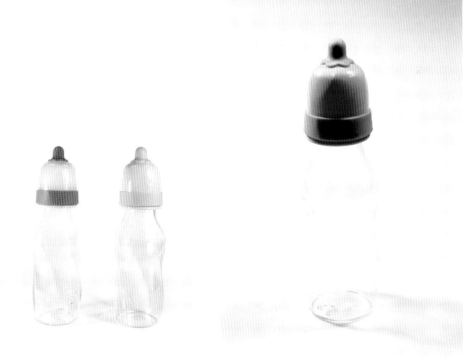

MILK BOTTLE
PC
2007
PATENT BY BASILIC

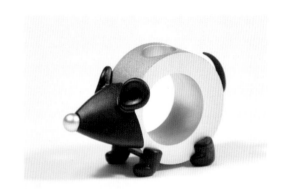

MOUSE PEN STAND
AL, ABS
2006
PATENT BY IDECO

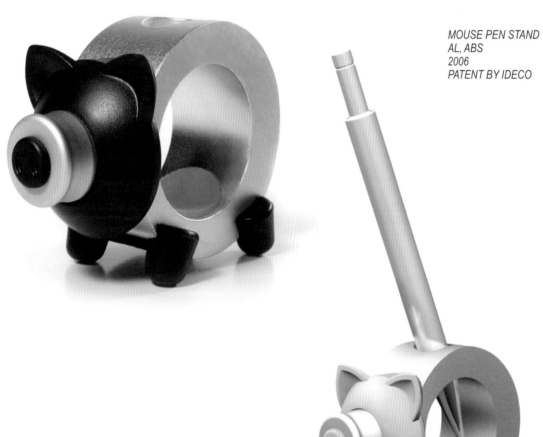

PIGGY PEN STAND
AL, ABS
2006
PATENT BY IDECO

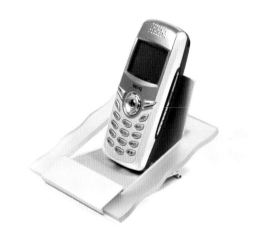

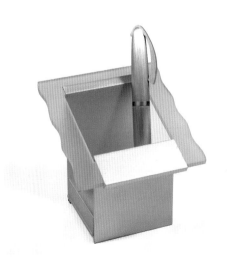

STATIONERY SET
ACRYLIC, AL, ETC.
2006
PATENT BY IDECO

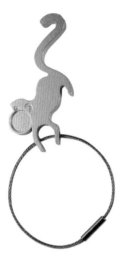

MONKEY (KEY-CHAIN)
AL & STEEL
2006
PATENT BY IDECO

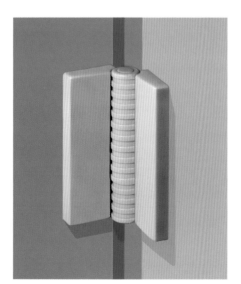

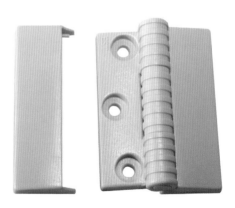

DOOR HINGE
PC / METAL
2006
PATENT BY I-SEN

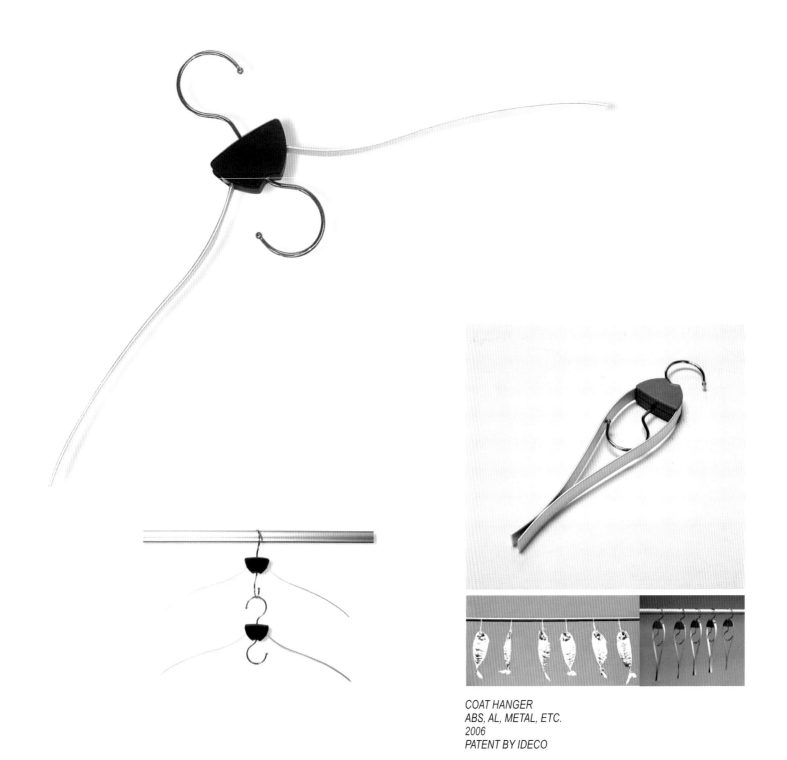

COAT HANGER
ABS, AL, METAL, ETC.
2006
PATENT BY IDECO

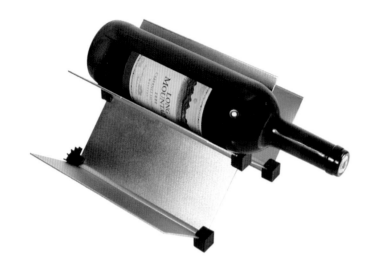

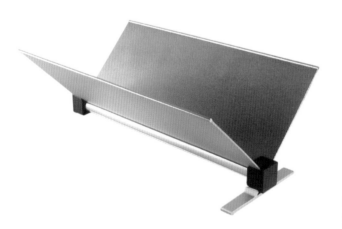
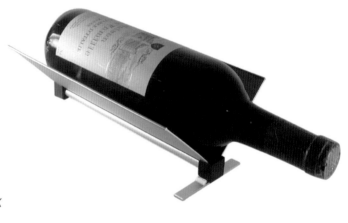

WINE BOTTLE RACK
ABS, AL, ETC.
2006
PATENT BY IDECO

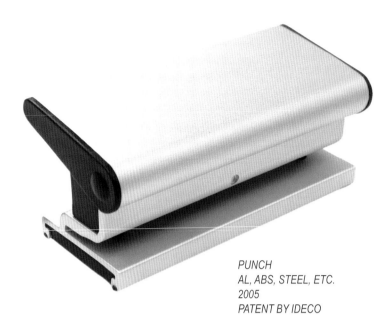

PUNCH
AL, ABS, STEEL, ETC.
2005
PATENT BY IDECO

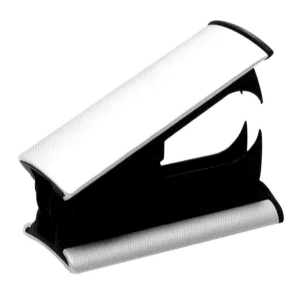

REMOVER
AL, ABS, STEEL, ETC.
2005
PATENT BY IDECO

NANO HAIR DRYER
TPR, PC, ABS, ETC.
2006
PATENT BY CHIA

NANO HAIR DRYER
TPR, PC, ABS, ETC.
2006
PATENT BY CHIA

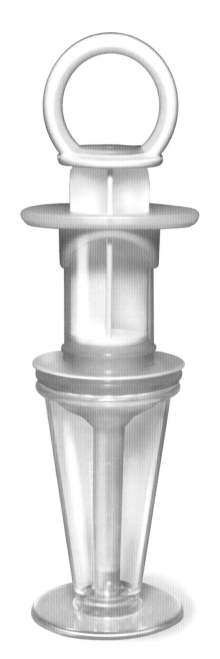

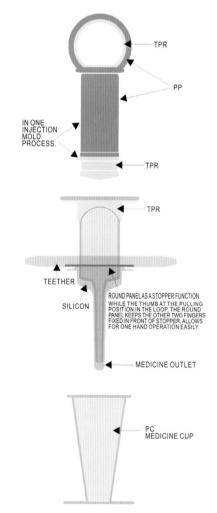

MEDICINE FEEDER
PP,TPR
2006
PATENT BY BASILIC

TPR

PP

IN ONE
INJECTION
MOLD
PROCESS.

TPR

TPR

TEETHER

SILICON

ROUND PANEL AS A STOPPER FUNCTION.
WHILE THE THUMB AT THE PULLING
POSITION IN THE LOOP, THE ROUND
PANEL KEEPS THE OTHER TWO FINGERS
FIXED IN FRONT OF STOPPER, ALLOWS
FOR ONE HAND OPERATION EASILY.

MEDICINE OUTLET

PC
MEDICINE CUP

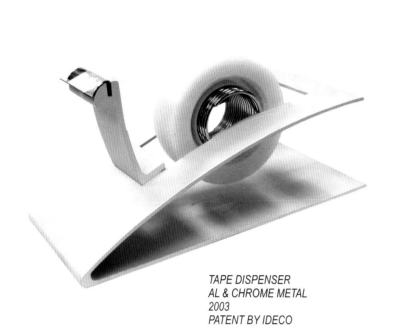

TAPE DISPENSER
AL & CHROME METAL
2003
PATENT BY IDECO

CLOCK
ABS
2002
PATENT BY POLYLIGHT

CALENDAR
AL & ABS
2003
PATENT BY IDECO

KITCHEN WARE
METAL, PP, TPR, ETC
2005
PATENT BY GOOD THINGS

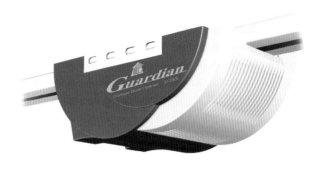

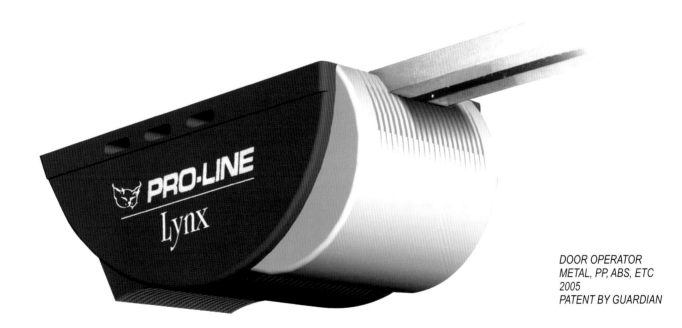

DOOR OPERATOR
METAL, PP, ABS, ETC
2005
PATENT BY GUARDIAN

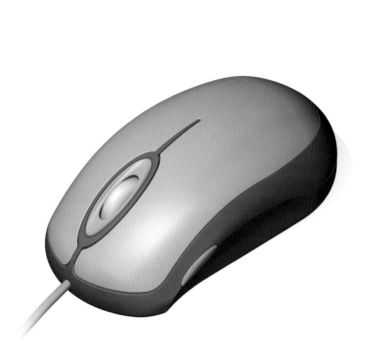

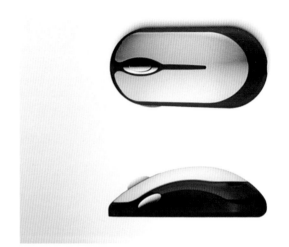

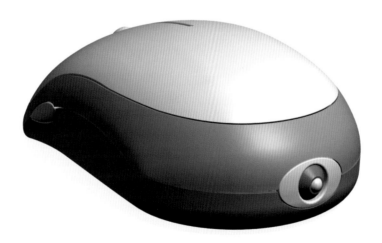

MOUSE + SCANER
ABS
2005
CO-DESIGNER: ZI-MING CHANG
PATENT BY CANMAX

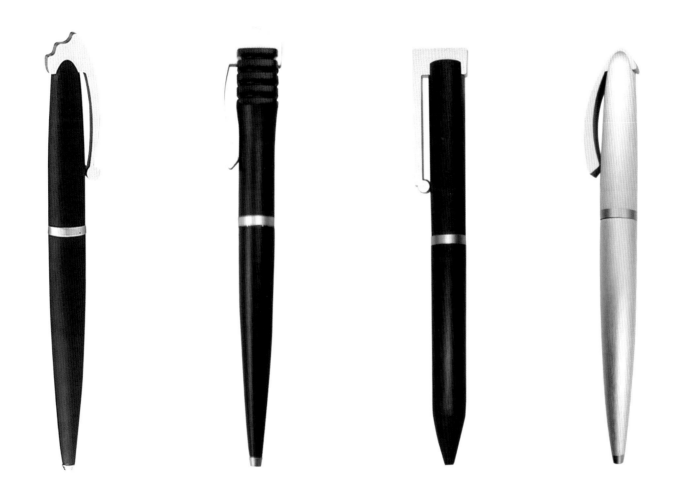

BALL POINT PEN
AL
2005
PATENT BY IDECO

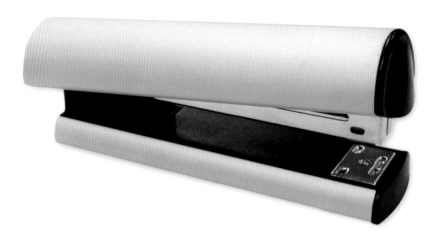

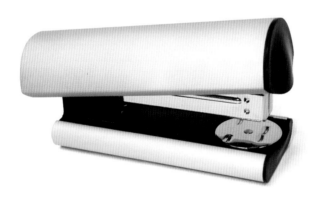

STAPLER
ABS, AL., AND & CHROME IRON
2003
PATENT BY IDECO

CLOCK(1)
ABS, AL, RUBBER, ETC.
2005
PATENT BY IDECO

CLOCK(2)
ABS, AL, RUBBER, ETC.
2005
PATENT BY IDECO

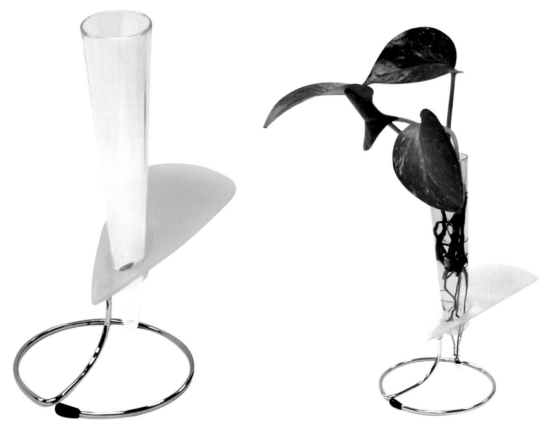

FLOWER VASE
CHROME METAL & ACRYLIC
2005
PATENT BY IDECO

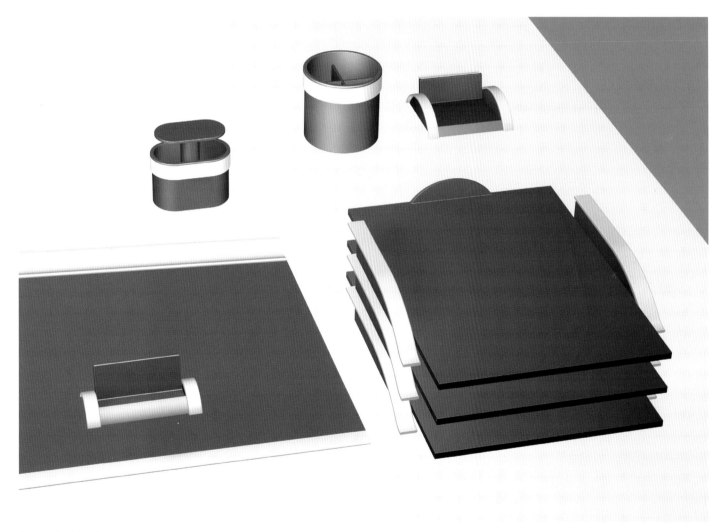

STATIONERY SET
AL, LEATHER, ABS, ETC.
2005
PATENT BY IDECO

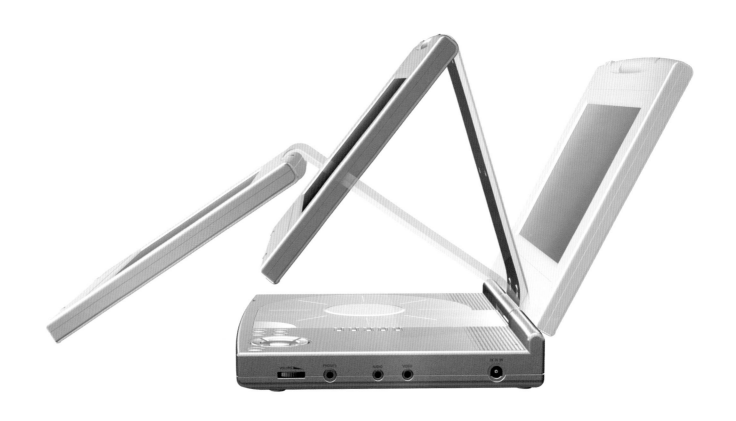

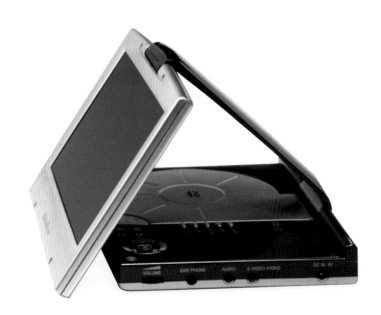

DVD PLAYER
ABS, METAL, ETC.
2005
PATENT BY FTI

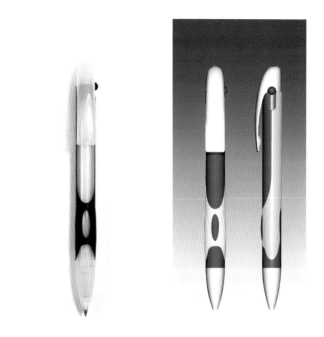

BALL POINT PEN
TPR & PC
2005
PATENT BY POLEEN

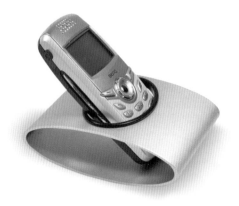

STATIONERY SET
ABS, AL, ETC.
2005
PATENT BY IDECO

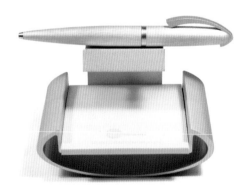

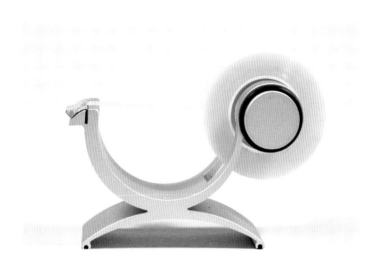

TAPE DISPENSER
AL & ABS
2005
PATENT BY IDECO

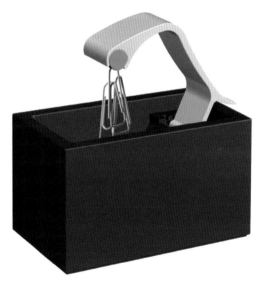

PAPER CLIP HOLDER
AL & ABS
2006
PATENT BY IDECO

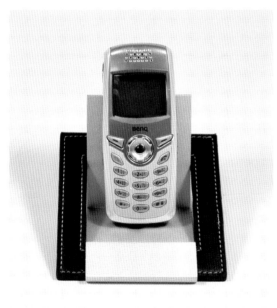

MOBILE HOLDER
AL & ABS
2005
PATENT BY IDECO

ULTRASONIC V. STIMULATOR
ABS & CHROME METAL
2004
PATENT BY YA-ZE

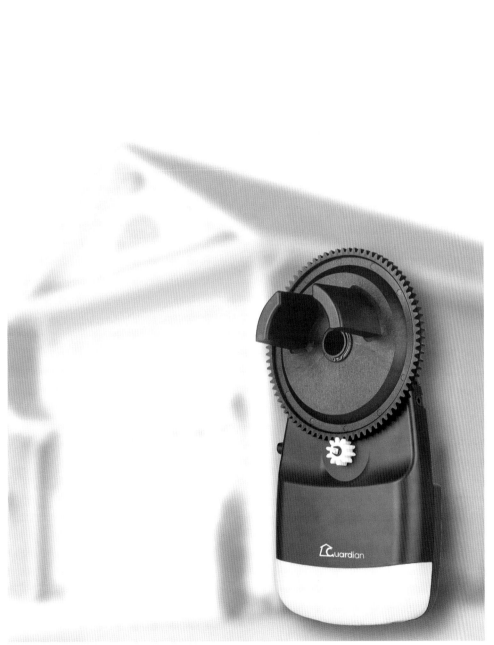

OPEARTOR
PC, PP, METAL, ETC.
2004
PATENT BY GUARDIAN

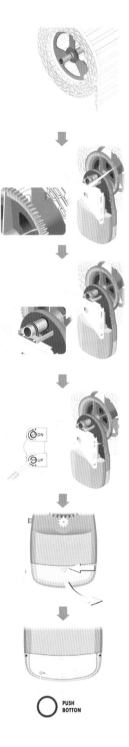

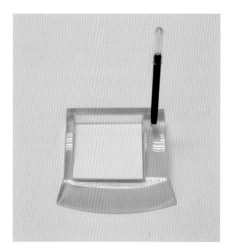
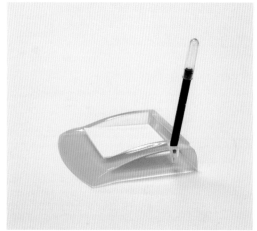

MEMO HOLDER w/ PEN STAND
ARCYLIC INJ. M.
2004
PATENT BY COMPANION

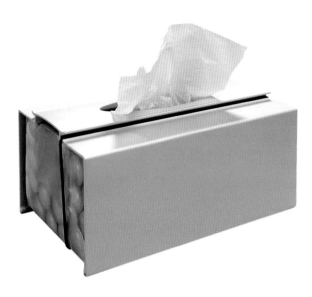

TISSUE HOLDER
AL, RUBBER RING, ABS, ETC.
2004
PATENT BY IDECO

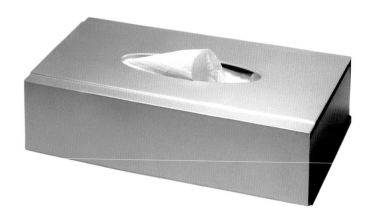

TISSUE HOLDER
AL, RUBBER RING, ABS, ETC.
2004
PATENT BY IDECO

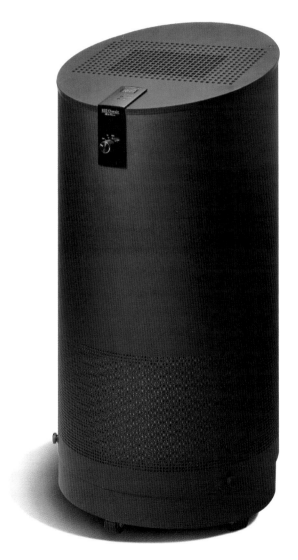

AIR CLEANER
STEEL, AL, ABS, RUBBER, ETC.
2004
PATENT BY I-SEN

► Post integration of odor-removal treatment

► Treatment of germicidal irradiation

► Treatment for interception of microorganisms

► Treatment for VOCs and odor removal

► Pretreatment of dust removal

TOY PICKER
AL, STEEL, PC, RUBBER, ETC.
2004
PATENT BY FORETEK

PAPER TRAY
ACRYLIC
2004
PATENT BY COMPANION

BUY AND ADD
AL, METAL, ACRYLIC, RUBBER, ETC.
2004
PATENT BY IDECO

ADD ON EDGE
AL, METAL, ACRYLIC, RUBBER, ETC.
2004
PATENT BY IDECO

HANGER CLIP

ORGANIZER
ABS, AL, METAL, ETC.
2004
PATENT BY IDECO

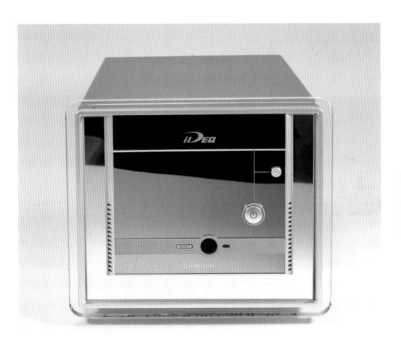

MINI PC
AL, ABS, ACRYLIC, ETC.
2004
PATENT BY BIOSTAR

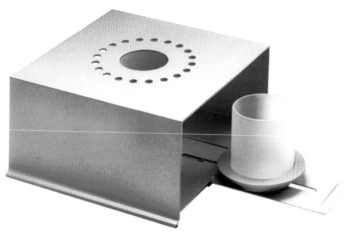

WARMER
AL, ABS, GLASS, METAL, ETC.
2004
PATENT BY IDECO

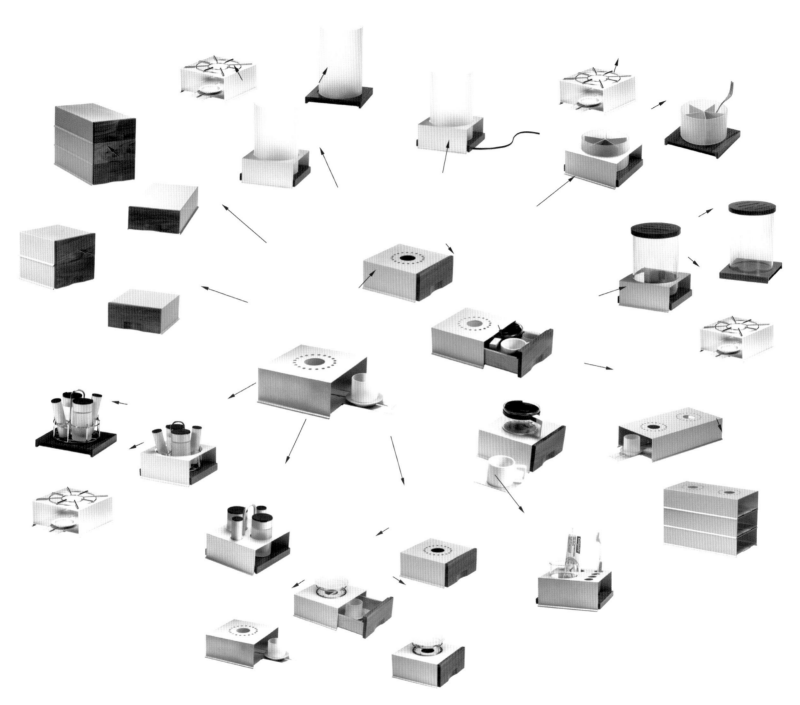

WARMER'S FAMILY
AL, ABS, GLASS, METAL, ETC.
2004
PATENT BY IDECO

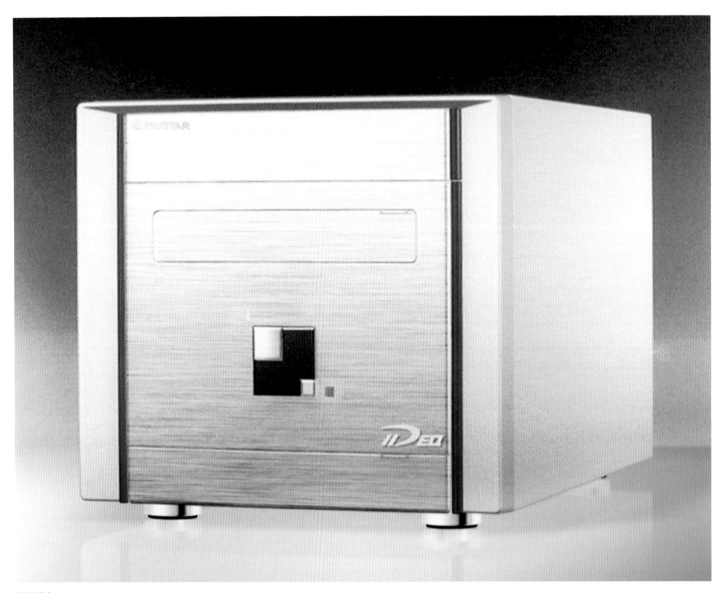

MINI PC
AL, ABS, ACRYLIC, ETC.
2004
PATENT BY BIOSTAR

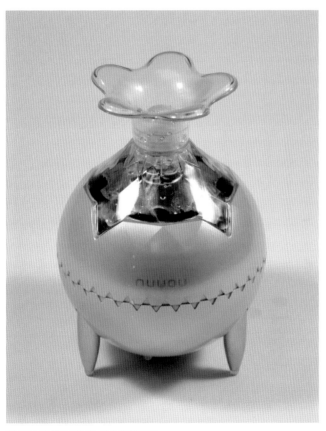

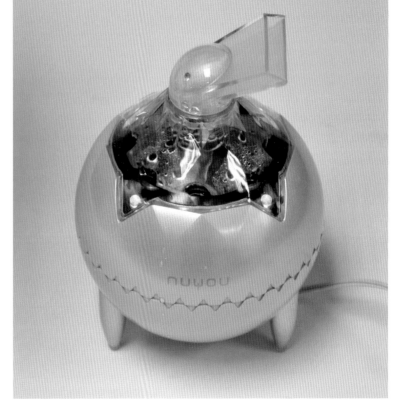

ULTRASONIC COOL-FUMIGATOR
ABS, ACRYLIC, AL, ETC.
2003
PATENT BY YA-ZE

GLASS BRICK SERIES
GLASS
2003
PATENT BY CICO

PENCIL SHARPER
ABS
2003
PATENT BY SDI

STAPLER FOR PACK.
ABS, CHROME METAL
2002
PATENT BY WELCOME

MAGNIFIER
GLASS, AL, RUBBER, ETC.
2003
PATENT BY IDECO

CD RACK
AL & CHROME METAL
2003
PATENT BY IDECO

LAMINATOR
ABS
2003
PATENT BY TEXYEAR

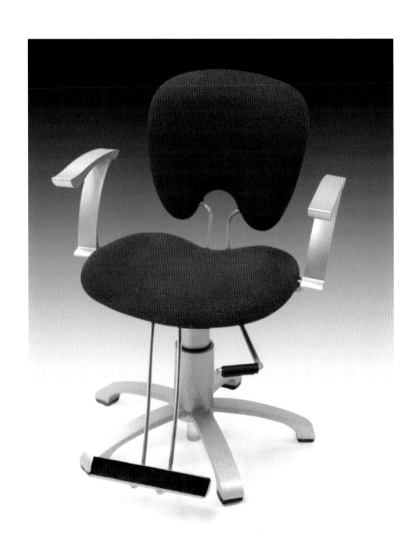

SALON CHAIR
ALUMINUN, METAL, CHROME, AND SPONGE
2003
PATENT BY BAO CHAIR

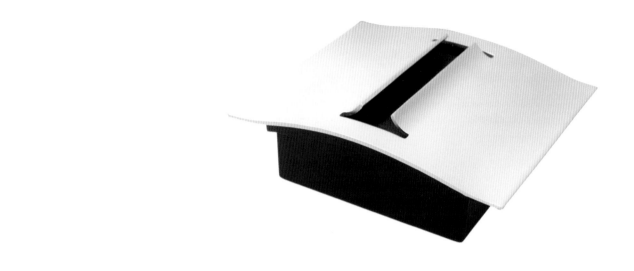

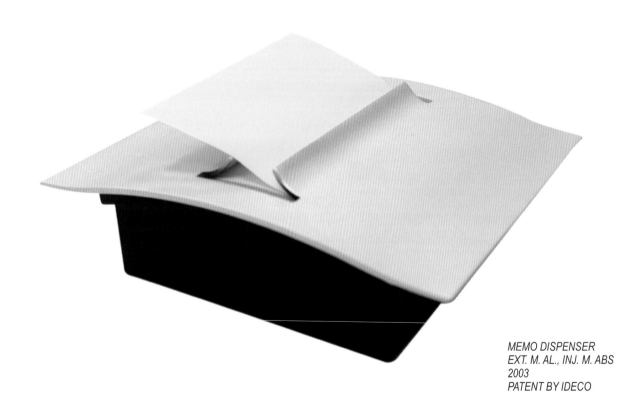

MEMO DISPENSER
EXT. M. AL., INJ. M. ABS
2003
PATENT BY IDECO

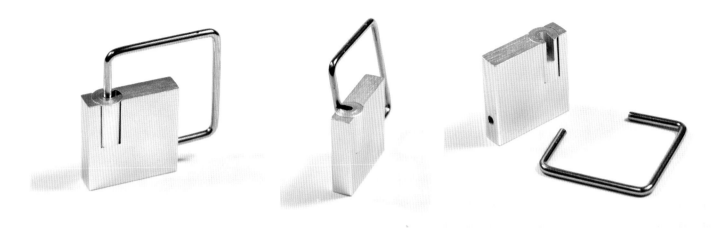

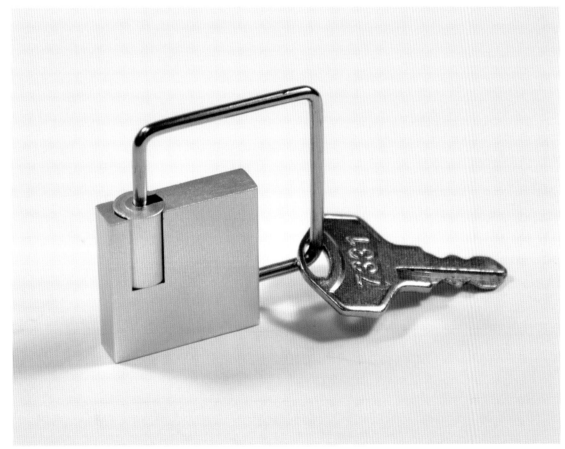

KEY CHAIN
CHROME METAL & AL
2003
PATENT BY IDECO

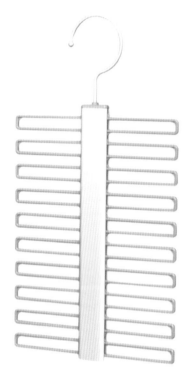

NECKTIE HANGER
PC, AL, METAL, ETC.
2003

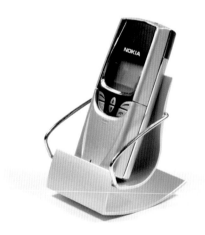

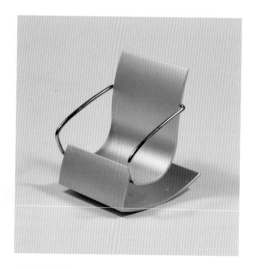

MOBILE PHONE HOLDER
AL, METAL, ETC.
2002
PATENT BY IDECO

HANGER
PC, AL, METAL, ETC.
2003

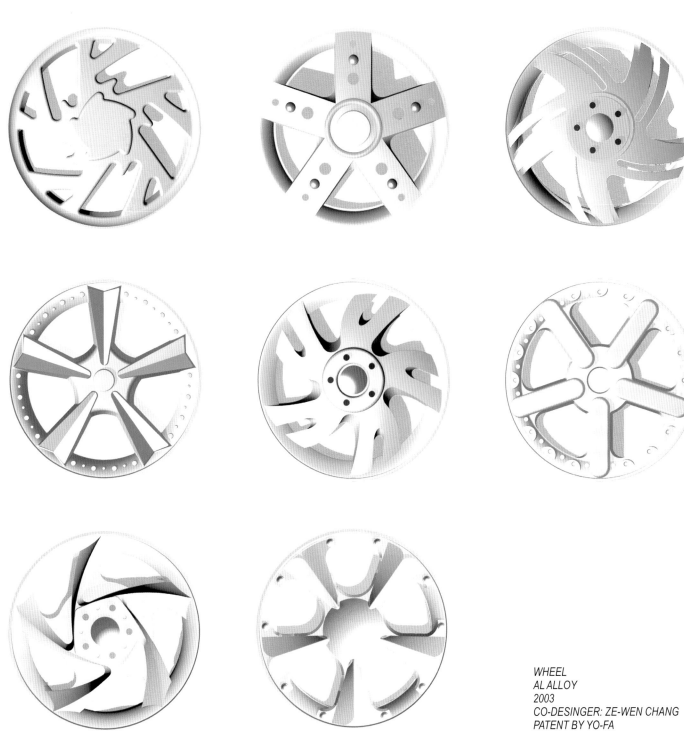

WHEEL
AL ALLOY
2003
CO-DESINGER: ZE-WEN CHANG
PATENT BY YO-FA

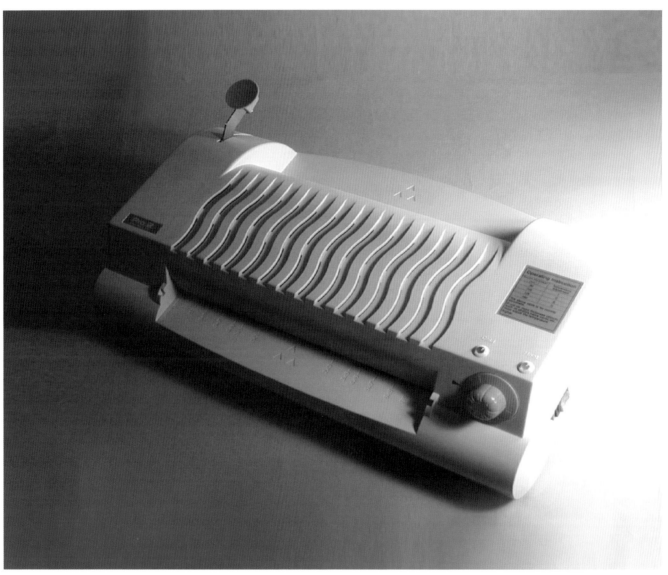

LAMINATOR
INJ. M. ABS
2002
PATENT BY PRO.2

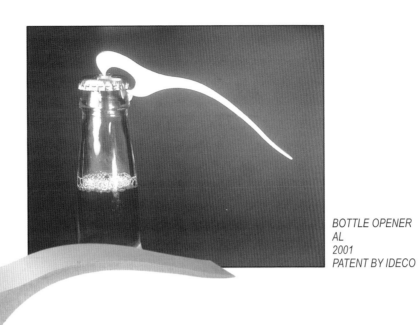

BOTTLE OPENER
AL
2001
PATENT BY IDECO

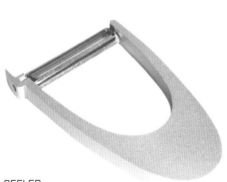

PEELER
METAL & AL
2002
PATENT BY IDECO

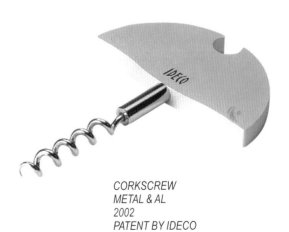

CORKSCREW
METAL & AL
2002
PATENT BY IDECO

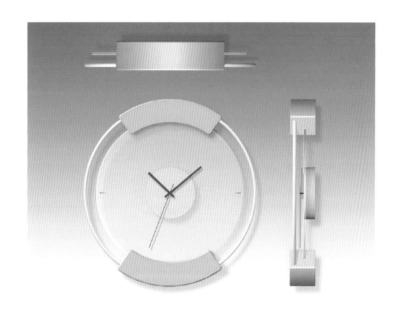

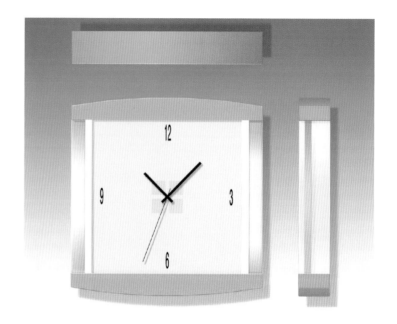

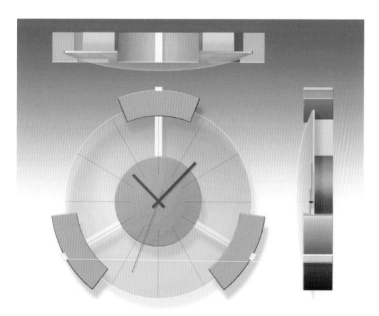

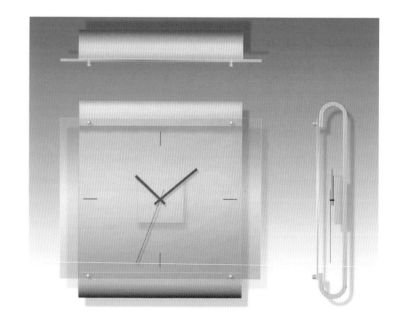

WALL CLOCK
PLYWOOD, GLASS, AND ALLUMINUN
2003
PATENT BY LI-THAI

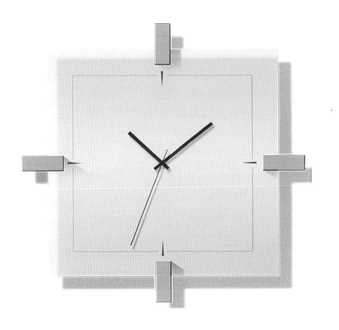

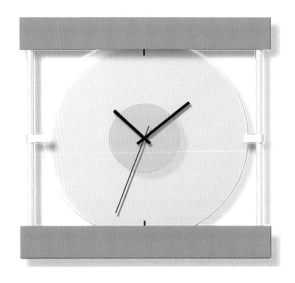

WALL CLOCK
PLYWOOD, GLASS, AND ALLUMINUN
2003
PATENT BY WEN'S

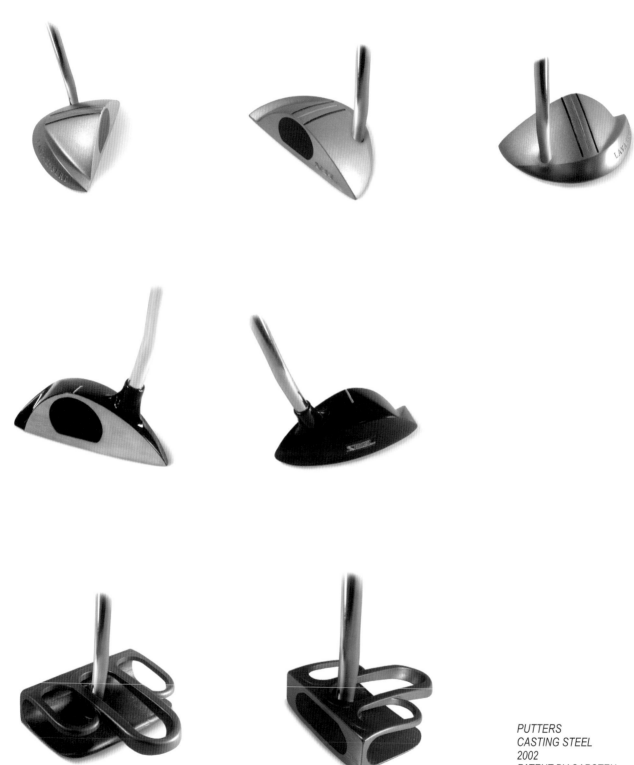

PUTTERS
CASTING STEEL
2002
PATENT BY CARSTEN

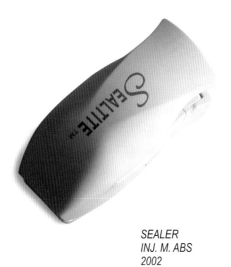
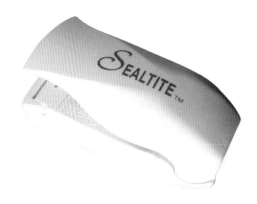

SEALER
INJ. M. ABS
2002
PATENT BY WELCOME

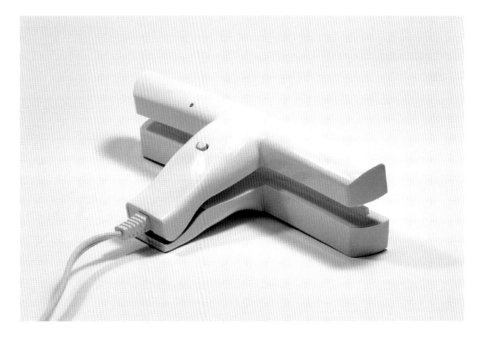

T- SEALER
INJ. M. ABS
2002
PATENT BY WELCOME

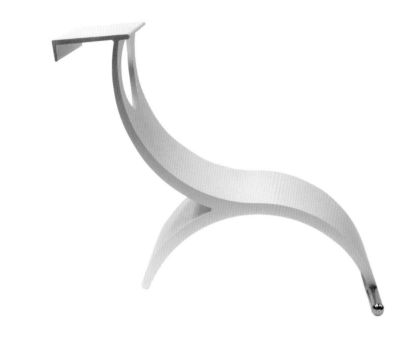

WINE BOTTLE HOLDER
AL
2002
PATENT BY IDECO

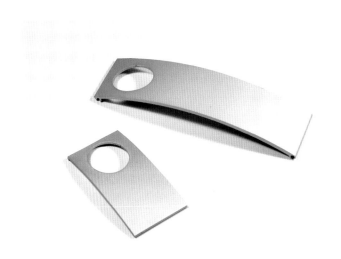

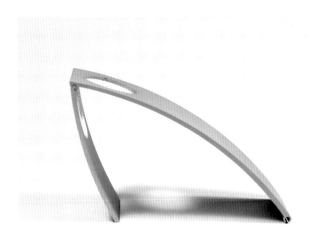

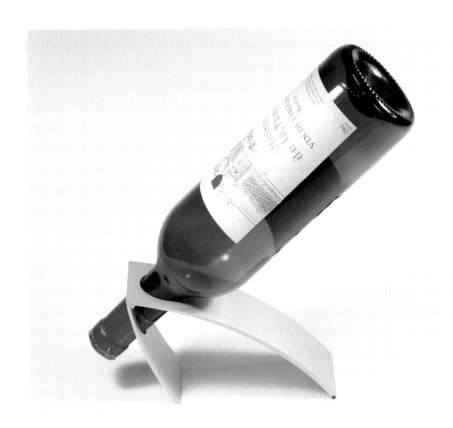

WINE BOTTLE HOLDER
AL
2002
PATENT BY IDECO

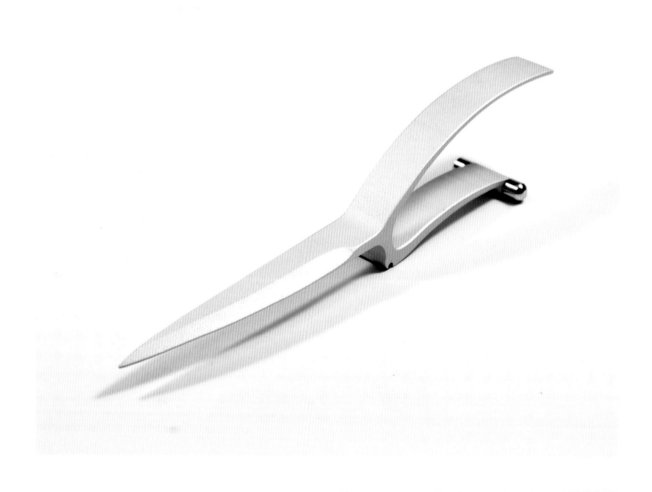

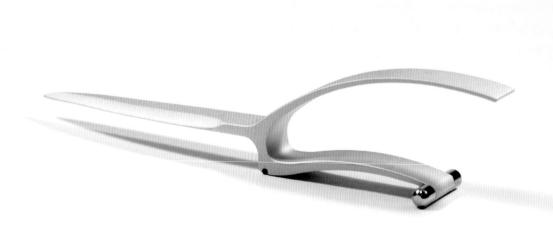

LETTER OPENER
AL & METAL CHROME
2002
PATENT BY IDECO

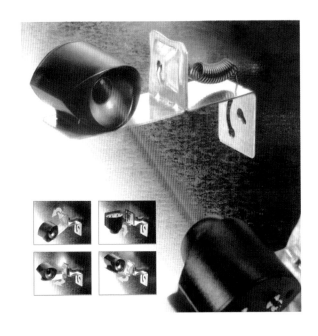

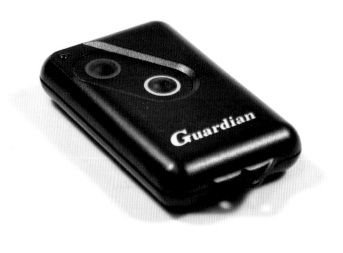

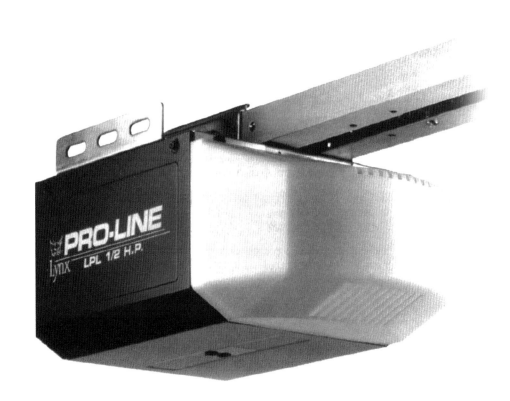

GARAGE DOOR OPENER
METAL, PP, ETC.
2001
PATENT BY GUARDIAN

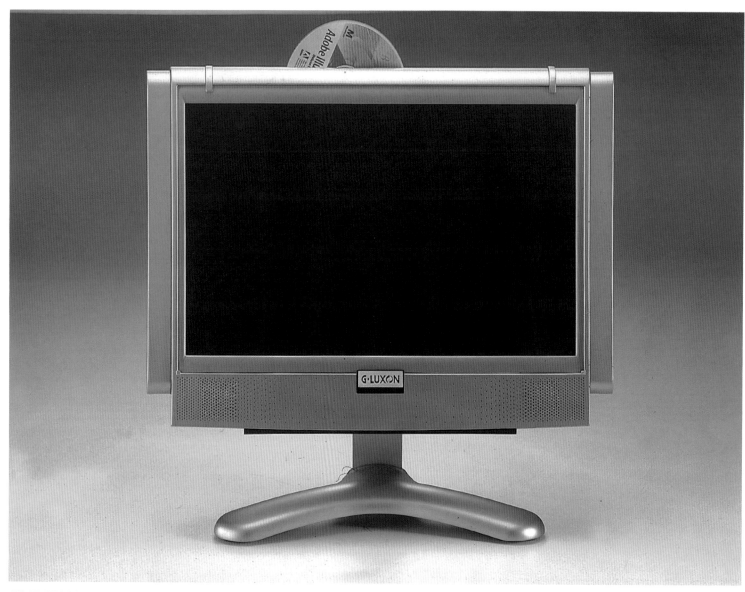

17"LCD CTV W/ DVD PLAYER
INJ. M. ABS CAB, ZINC ALLOY BASE
2001
PATENT BY G-LUXON

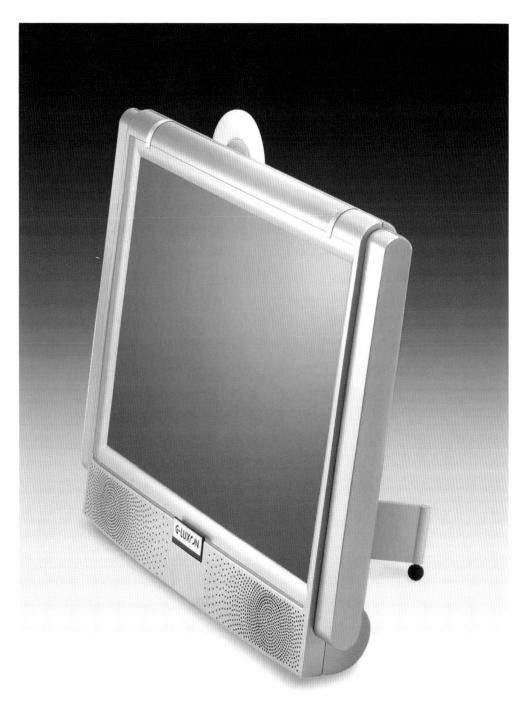

17"LCD CTV W/ DVD PLAYER
INJ. M. ABS CAB, AL BASE
2001
PATENT BY G-LUXON

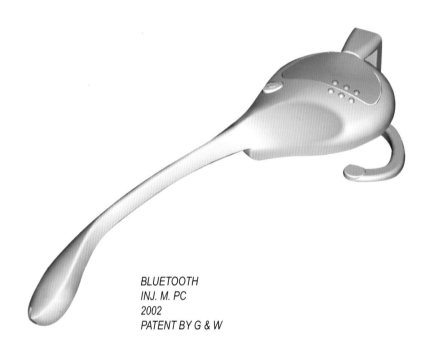

BLUETOOTH
INJ. M. PC
2002
PATENT BY G & W

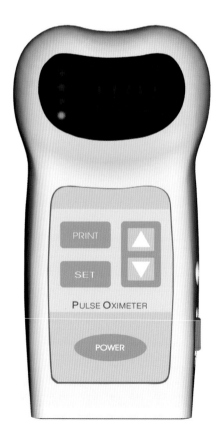

PRINT ▲

SET ▼

PULSE OXIMETER

POWER

PULSE OXIMETER
ABS
2001
PATENT BY BESMED

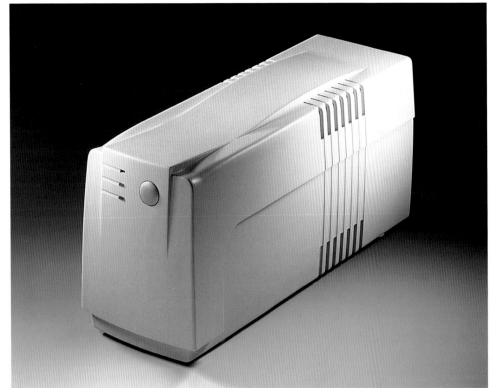

UPS
ABS
2000
PATENT BY APOLLO

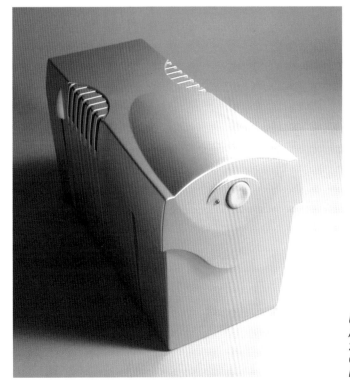

UPS
ABS
2001
CO-DESIGNER: ZE-WEN CHANG
PATENT BY APOLLO

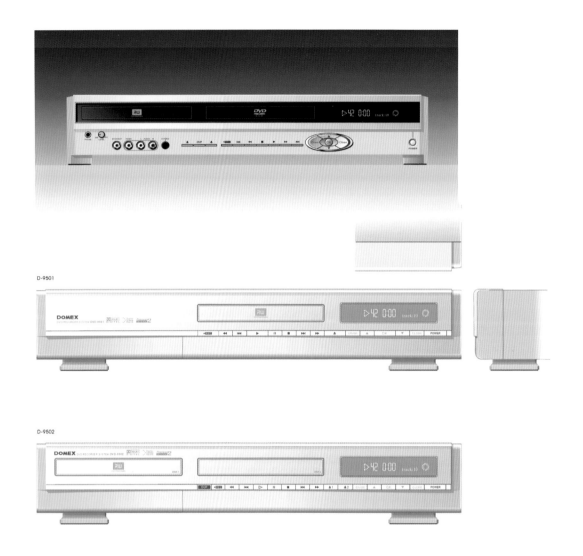

D-9501

D-9502

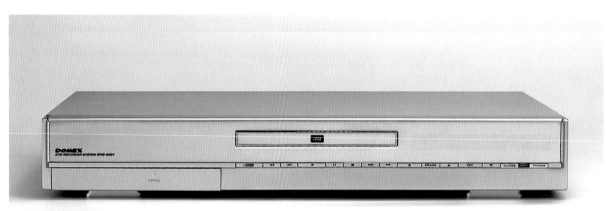

DVD
AL, ACRYLIC, AND ABS
2001
PATENT BY DOMEX

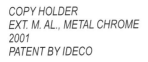

COPY HOLDER
EXT. M. AL., METAL CHROME
2001
PATENT BY IDECO

COPY HOLDER
EXT. M. AL., METAL CHROME
2001
PATENT BY IDECO

STATIONERY SET
ACRYLIC, AL, METAL, ETC
1999
PATENT BY IDECO

LETTER OPENER
INJ. M. ACRYLIC
2000
PATENT BY COMPANION

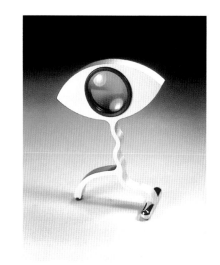

MAGNIFYING GLASS
ACRYLIC, RUBBER, AL, METAL, ETC
2000
PATENT BY IDECO

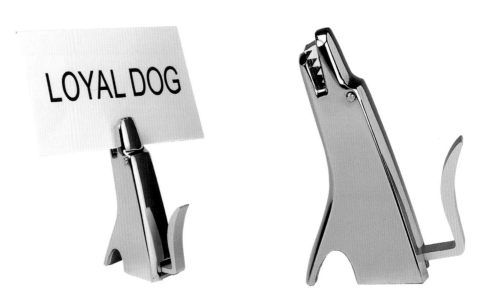

MEMO HOLDER
AL, STEEL, ZING ALLOY, ETC
2000
PATENT BY IDECO

130

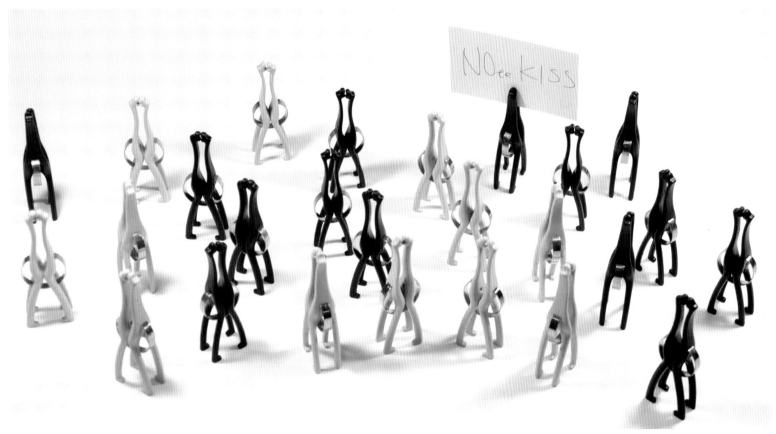

NOte KISS (MEMO CLIP)
ABS & CHROME METAL
2000
PATENT BY IDECO

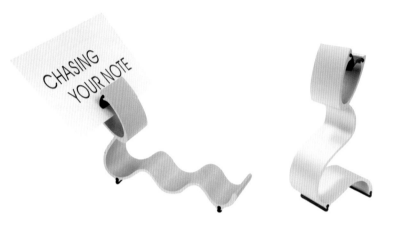

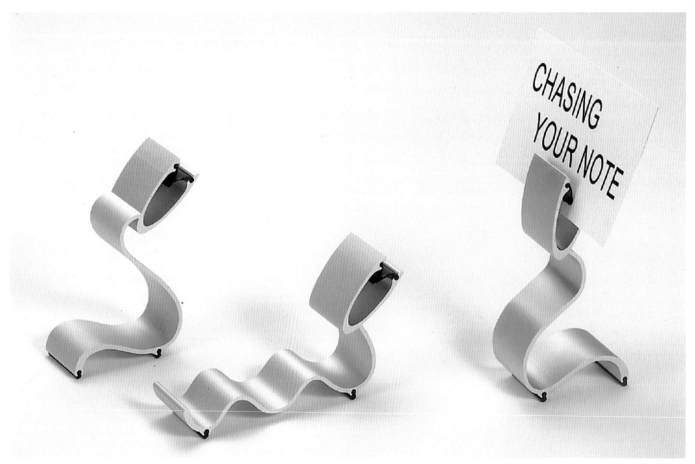

MEMO CLIP
AL
2000
PATENT BY IDECO

REMINDER
AL, ABS, LEATHER BAND, ETC.
2000
PATENT BY YOUNG

HEALTH CARE
ABS
1999
PATENT BY K & G

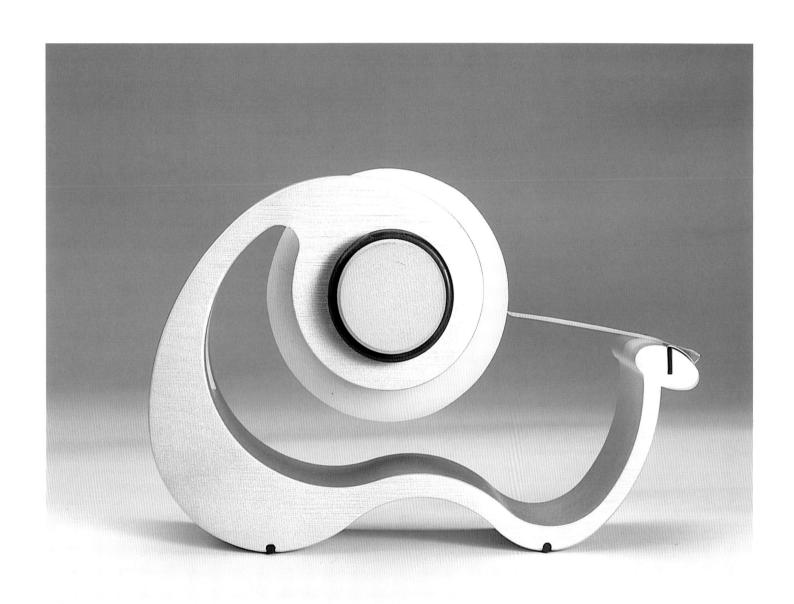

TAPE DISPENSER
EXT. M. AL
1999
PATENT BY IDECO

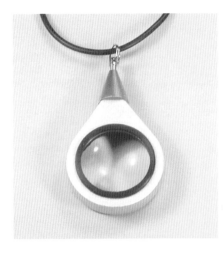

NECKLACE + MAGNIFIER
AL + GLASS
1999
PATENT BY IDECO

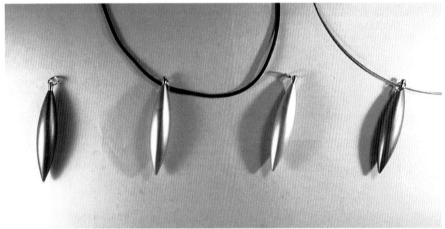

NECKLACE + PEN
AL
1999
PATENT BY IDECO

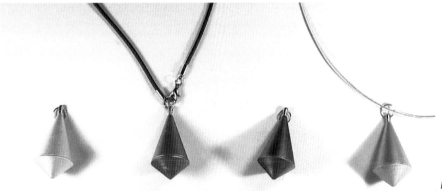

NECKLACE + BOX
AL
1999
PATENT BY IDECO

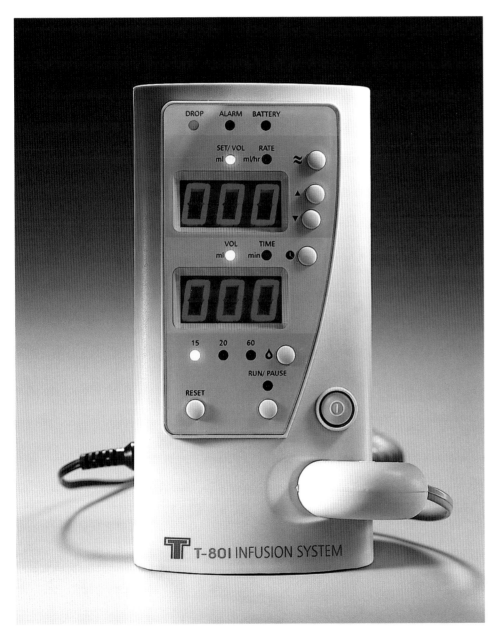

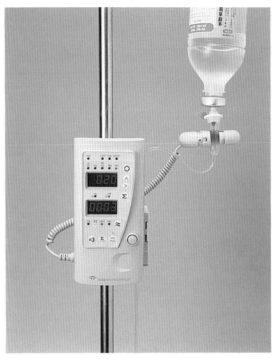

INFUSION SYSTEM
ABS, ACRYLIC, ETC.
1995
PATENT BY K & G

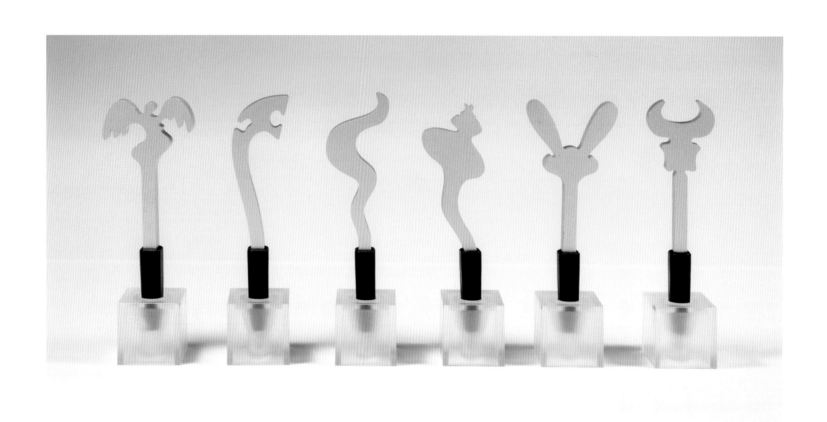

PEN STAND
AL, ABS, ACRYLIC, ETC
1999
PATENT BY IDECO

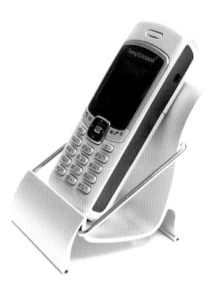

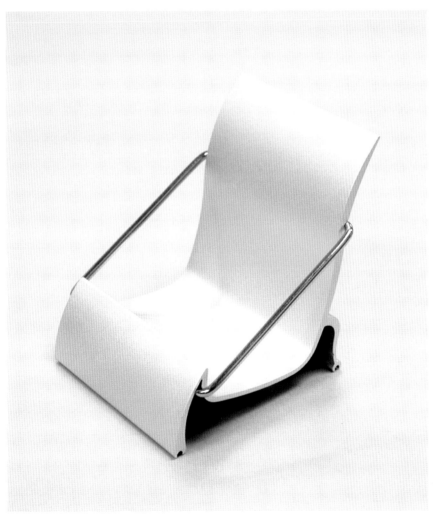

MOBILE PHONE HOLDER
AL & CHROME WIRE
1999
PATENT BY IDECO

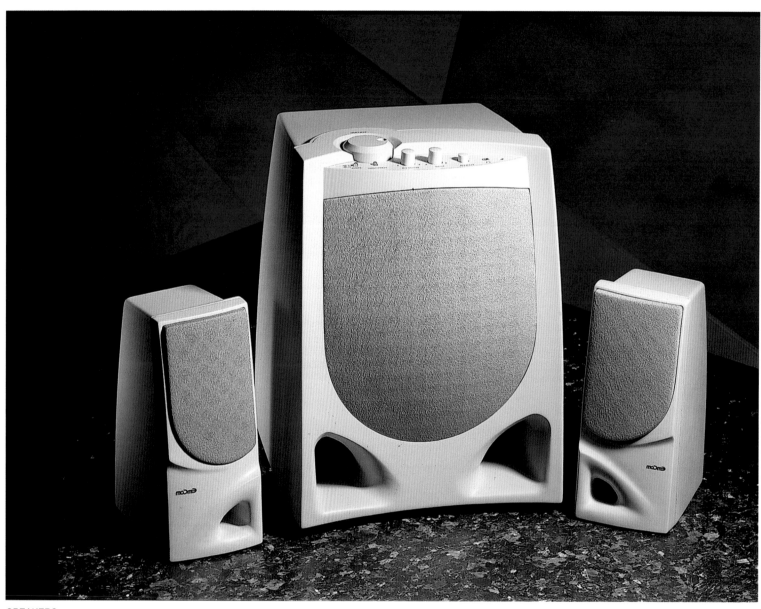

SPEAKERS
ABS
1998
PATENT BY EMCOM

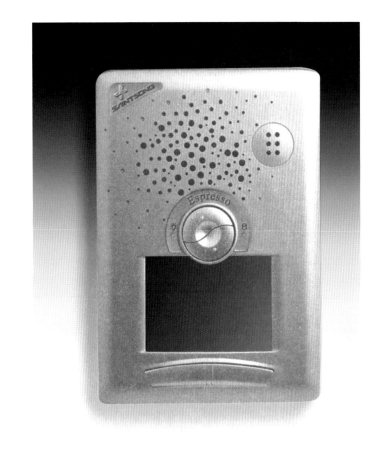

POCKET PC
ABS
1998
PATENT BY TSS

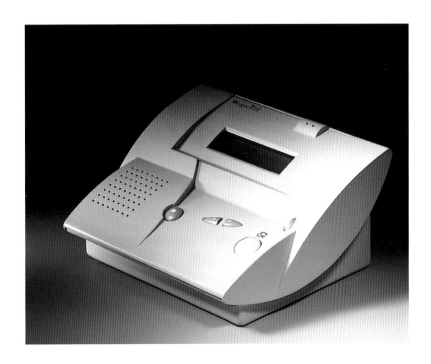

MAGIC TALK
ABS
1997
PATENT BY SOYO

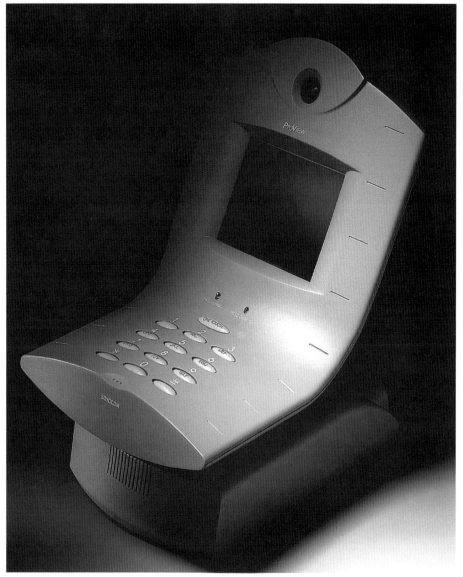

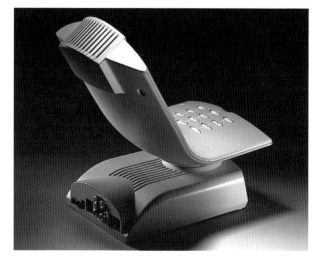

VIDEO PHONE
ABS
1997
PATENT BY SOYOCOM

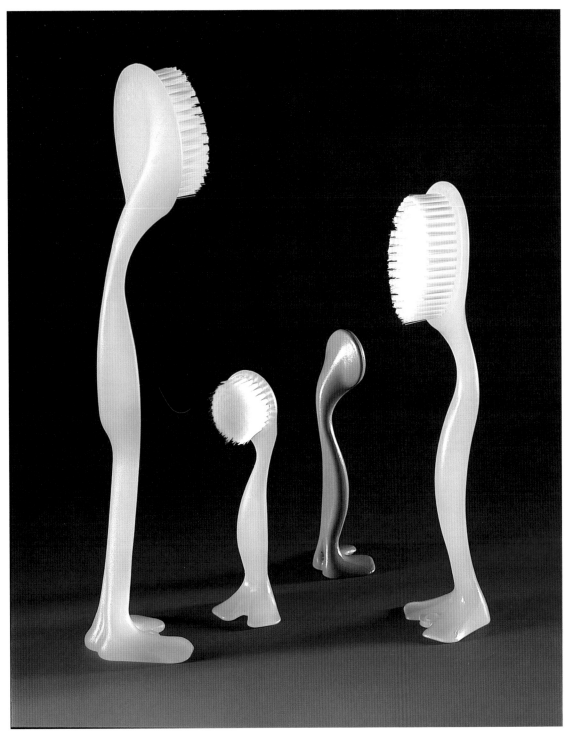

BATH BRUSHES
PP, PE, RUBBER, ETC
1997
PATENT BY CANSHOW

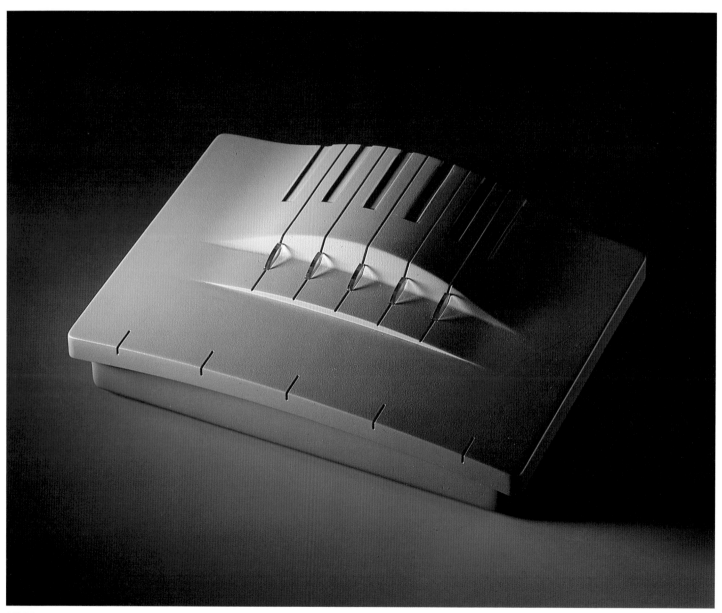

MODEM
ABS
1996
PATENT BY GVC

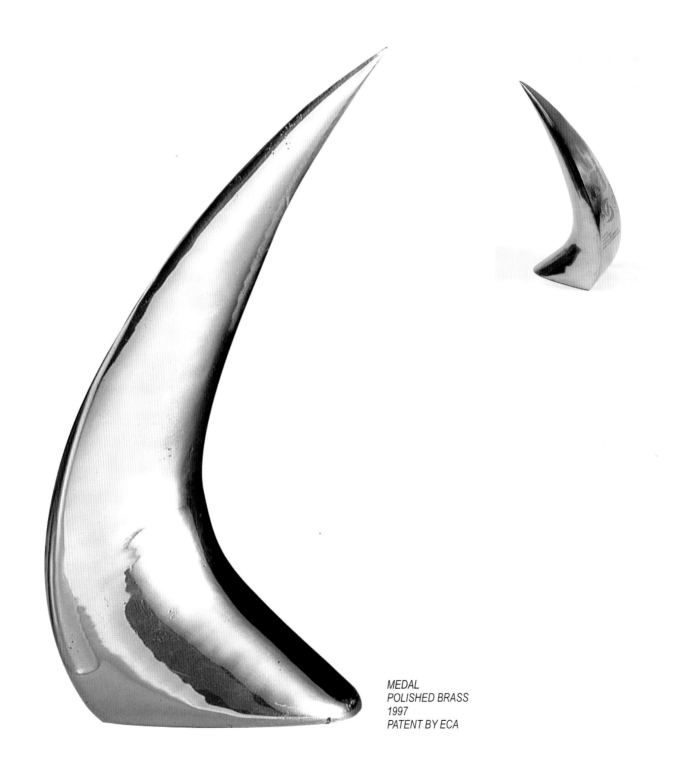

MEDAL
POLISHED BRASS
1997
PATENT BY ECA

PC CAMERA(2)
ABS
1998
PATENT BY CELLVISION

HEATER CONTROLLER
ABS
1995
PATENT BY JOE

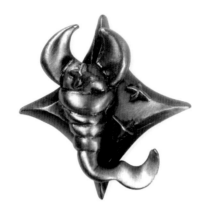
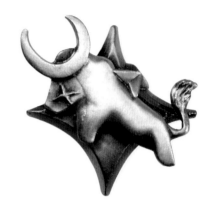

BROOCH
SILVER
1996
PATENT BY WEN'S

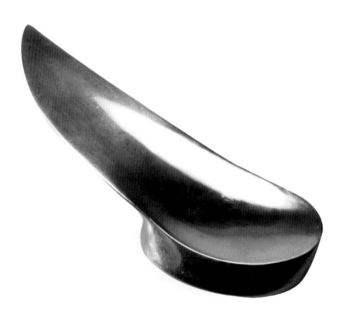

LETTER OPENER
SILVER
1996
PATENT BY WEN'S

 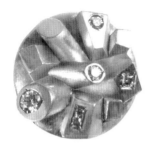 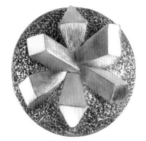 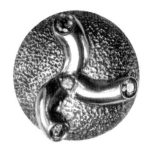

PIN
SILVER + DIAMOND CRYSTAL
1996
PATENT BY WEN'S

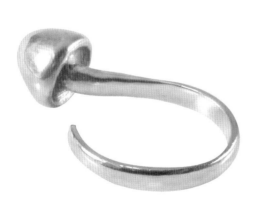 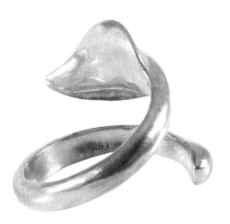

RING
SILVER
1996
PATENT BY WEN'S

RING
SILVER
1996
PATENT BY WEN'S

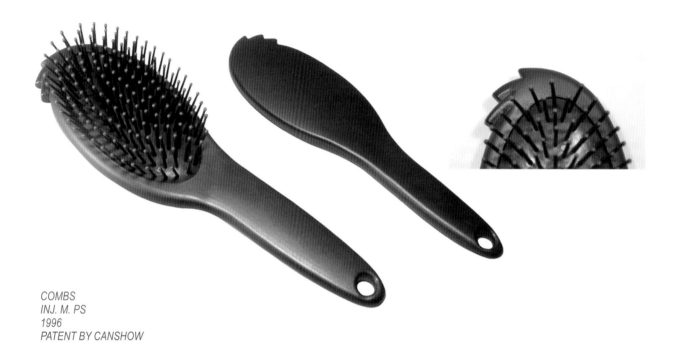

COMBS
INJ. M. PS
1996
PATENT BY CANSHOW

COMB
PS
1996
PATENT BY CANSHOW

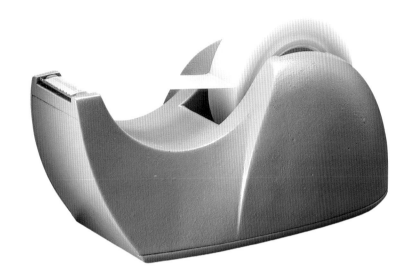

TAPE DISPENSER
ABS
1997
PATENT BY DAILYLINE

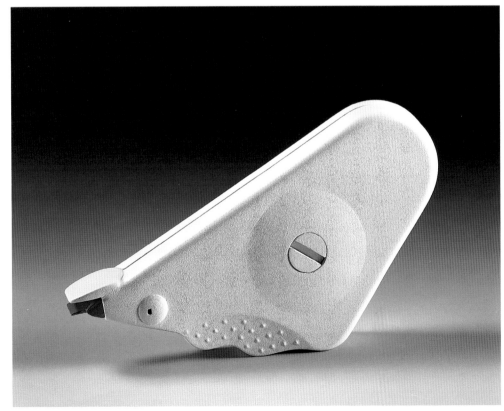

CLEAN TAPE DISPENSER
ABS
1997
PATENT BY DAILYLINE

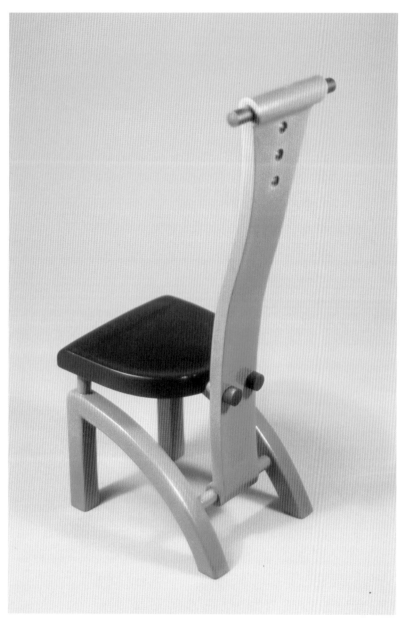

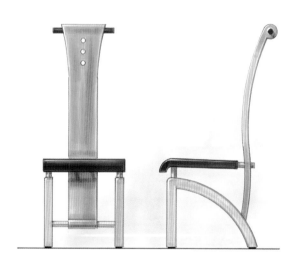

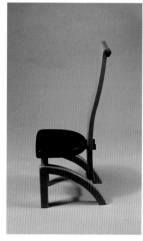

DINER CHAIR
MAPLE
1998
PATENT BY YIH LIN

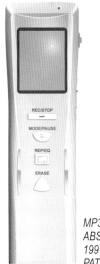

MP3
ABS
1997
PATENT BY KINPO

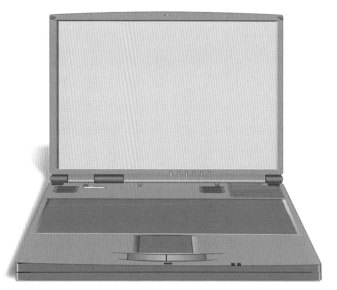

NOTEBOOK
ABS
1996
PATENT BY INNOVACE

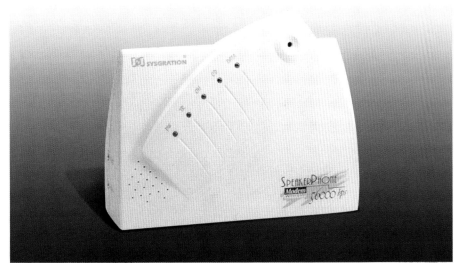

MODEM
ABS
1996
PATENT BY EMCOM

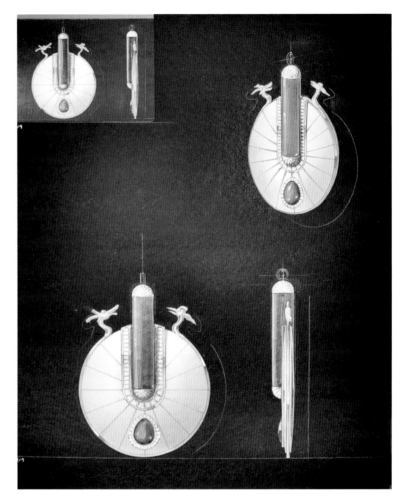

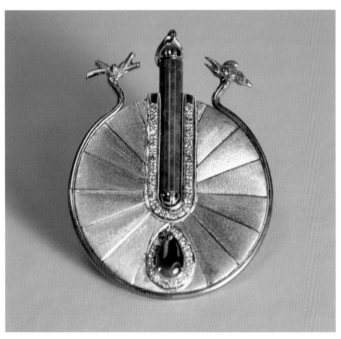

NECKLACE
PLATINUM, GOLD, DIAMOND, AND JADE
1996
PATENT BY WEN'S

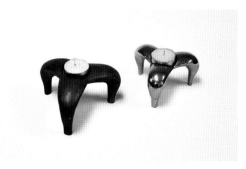

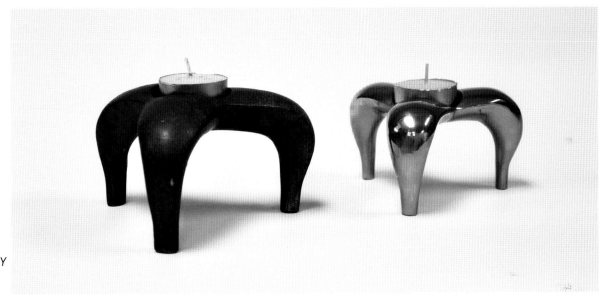

CANDLE STAND
BRASS, ZINC ALLOY
1996
PATENT BY WEN'S

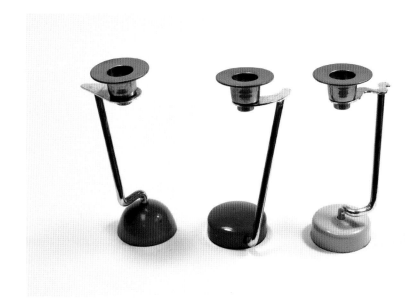

CANDLE STAND
CHROME METAL
1996
PATENT BY WEN'S

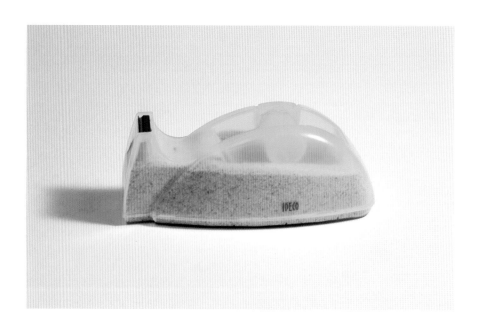

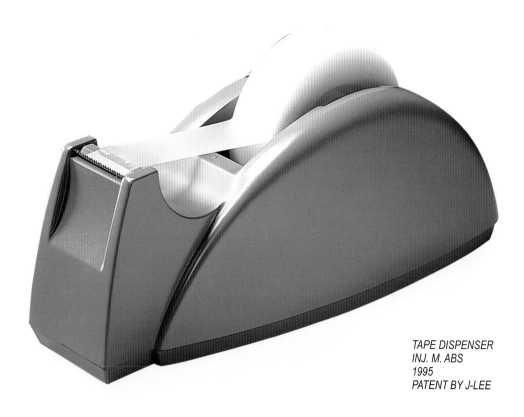

TAPE DISPENSER
INJ. M. ABS
1995
PATENT BY J-LEE

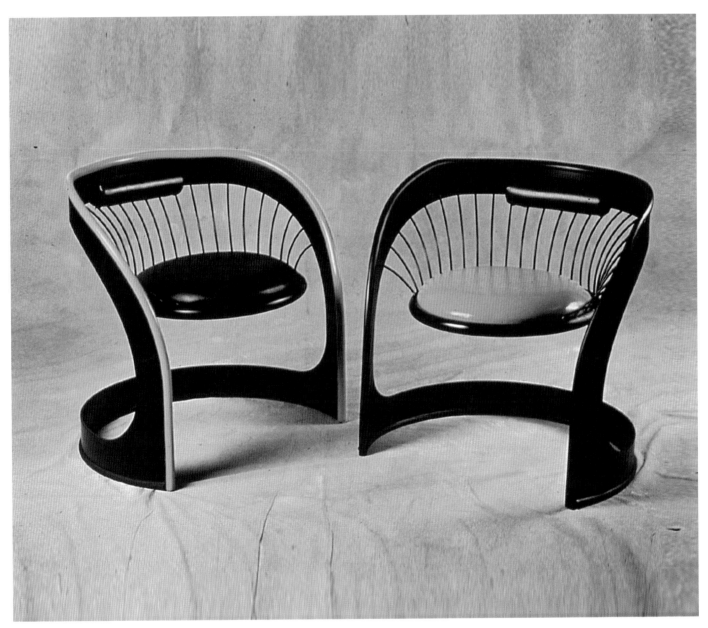

RHYTHM OF EYELASHES (ARM CHAIR)
METAL, RUBBER, SPONGE, ETC.
1995
PATENT BY WEN'S

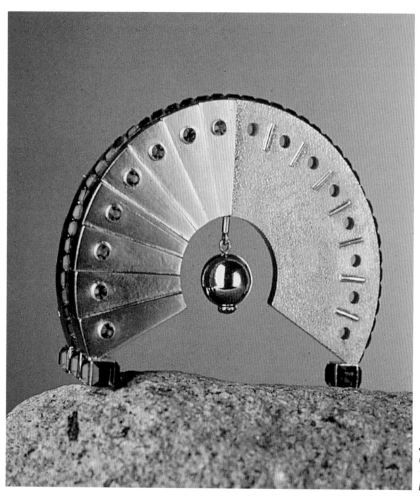

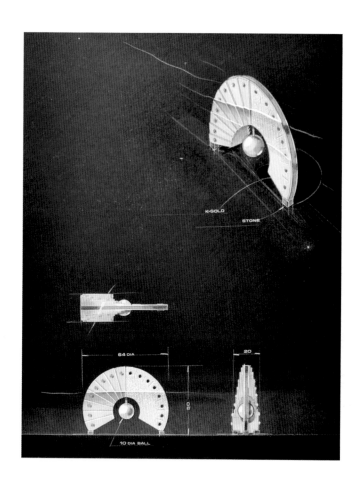

JEWELRY (LOVE STORY)
GOLD, BLUE STONE
1994
PATENT BY WEN'S

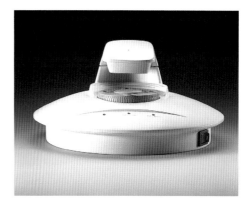

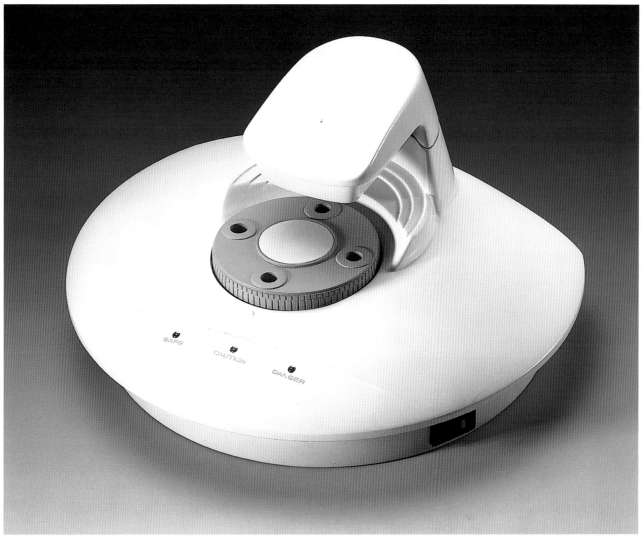

LENS TESTING INSTRUMENT
INJ. M. ABS
1995
PATENT BY ITRY

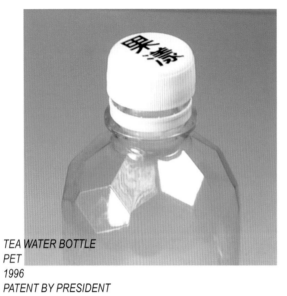

TEA WATER BOTTLE
PET
1996
PATENT BY PRESIDENT

SALAD OIL BOTTLE
PET
1996
PATENT BY PRESIDENT

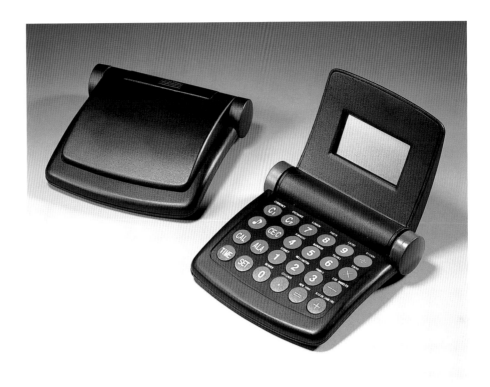

CALCULATOR
ABS
1995
PATENT BY CHIN TAI

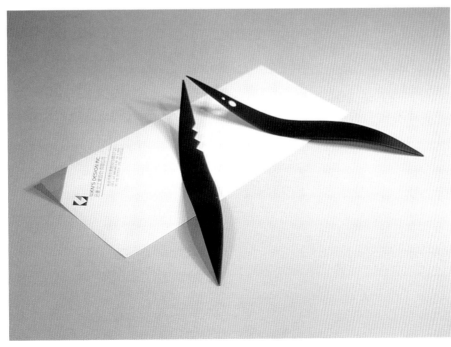

LETTER OPENER
BRASS
1995
PATENT BY WEN'S

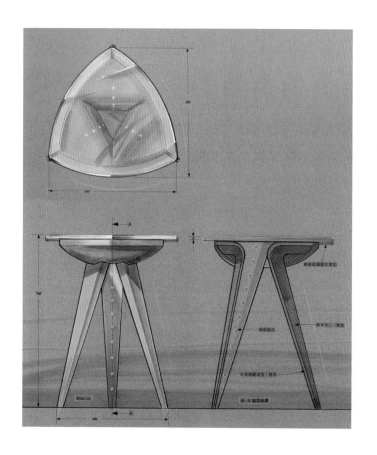

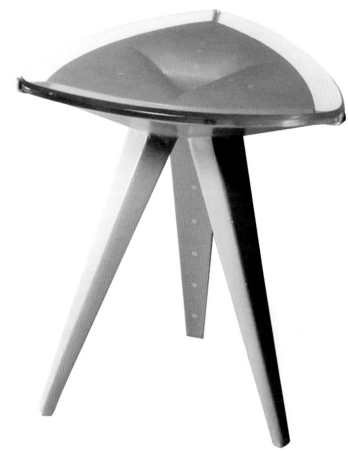

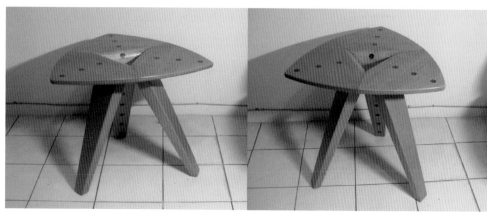

TABLE & CHAIR
MAPLE, GLASS
1994
PATENT BY WEN'S

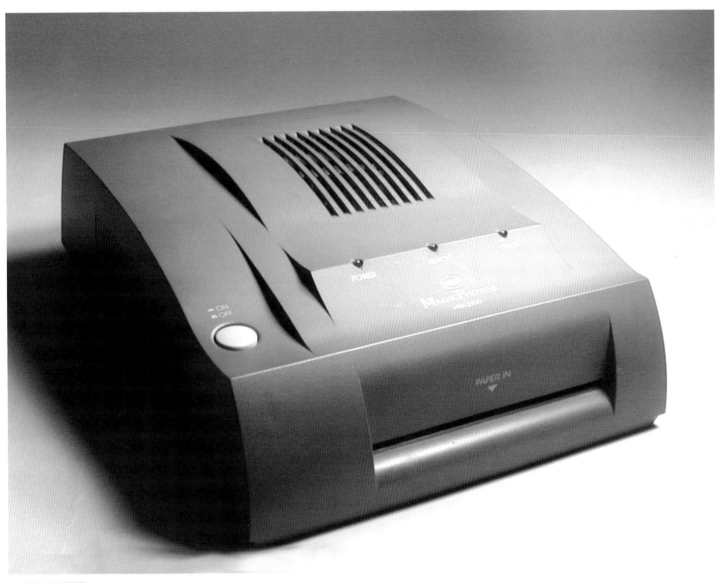

PHOTO PRINTER
INJ. M. ABS
1996
PATENT BY HWA-WEI

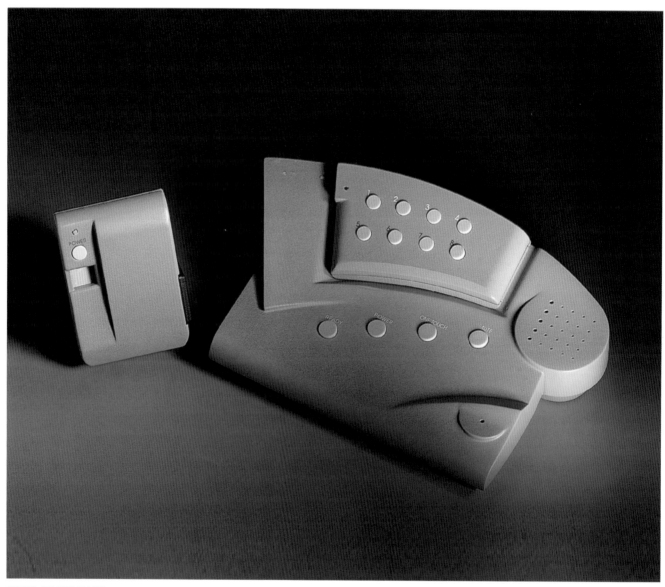

VOCAL CONTROLLER
INJ. ABS
1995
PATENT BY OPTICON

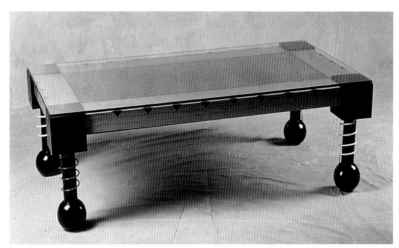

TEA TABLE #11
WOOD W/ LACQUERED
1995
PATENT BY WEN'S

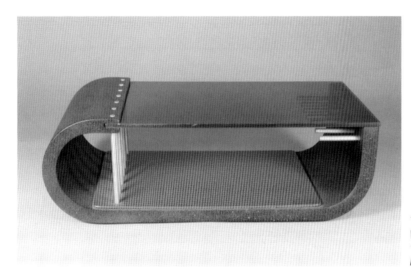

TEA TABLE #12
WOOD W/ LACQUERED
1995
PATENT BY WEN'S

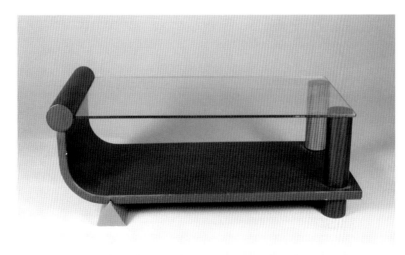

TEA TABLE #13
WOOD W/ LACQUERED
1995
PATENT BY WEN'S

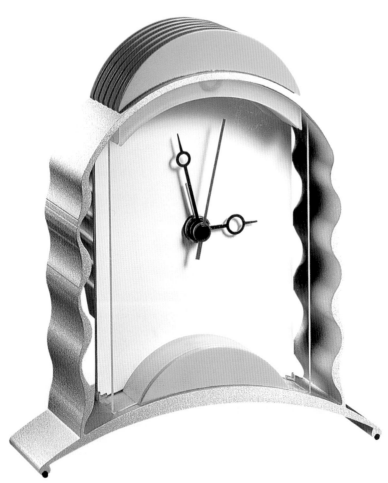

ART DECO CLOCK
AL & ACRYLIC
1995
PATENT BY HOYO

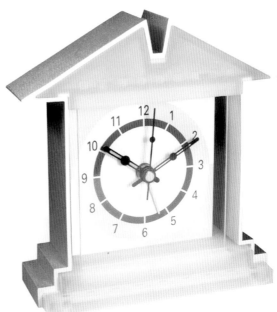

CLOCK
AL, ACRYLIC, ETC.
1995
PATENT BY HOYO

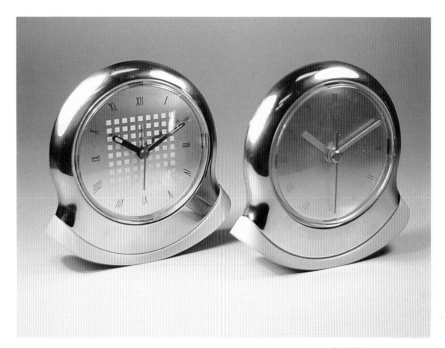

CLOCK
STEEL, ACRYLIC, ETC.
1995
PATENT BY WEN'S

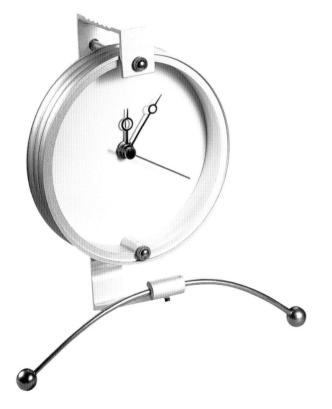

CLOCK
AL, ACRYLIC, METAL, ETC.
1995
PATENT BY HOYO

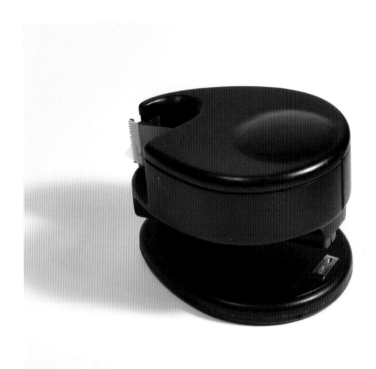

TAPE DISPENSER + STAPLER
ABS
1995
PATENT BY DAILYLINE

PACK TAPE DISPENSER
ABS + PC
1995
PATENT BY DAILYLINE

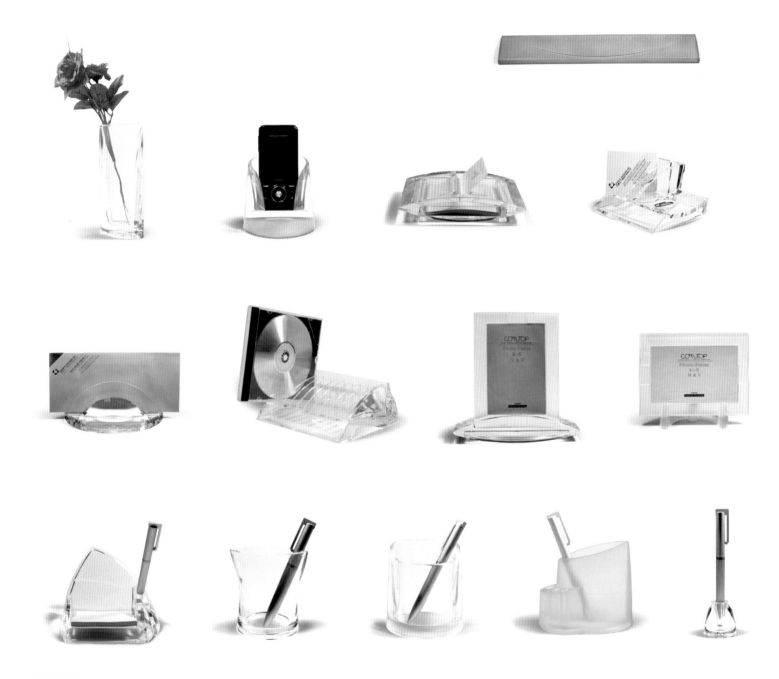

TABLE TOP
ACRYLIC
1995
PATENT BY COMPANION

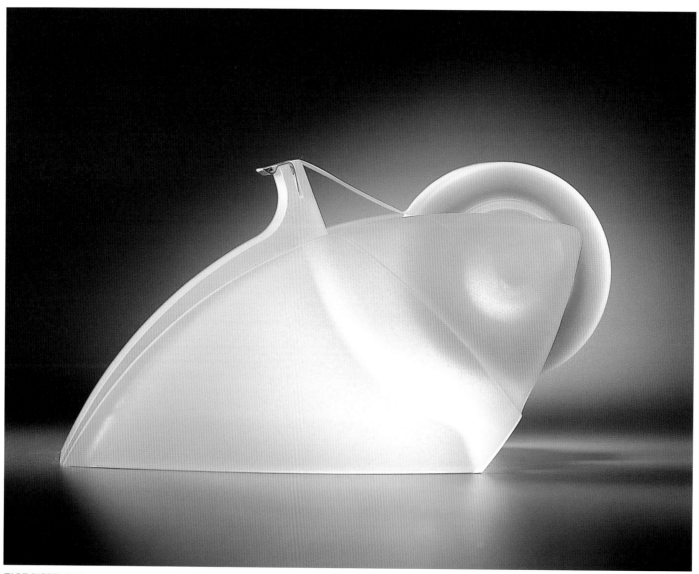

TAPE DISPENSER
INJ. M. ACRYLIC
1994
PATENT BY COMPAINION

PHONE SET
INJ. M. ABS
1994
PATENT BY H& I

PHONE SET
INJ. M. ABS
1994
PATENT BY H& I

SCANNER (1)
ABS
1994
PATENT BY ITRY

SCANNER (2)
ABS
1994
PATENT BY ITRY

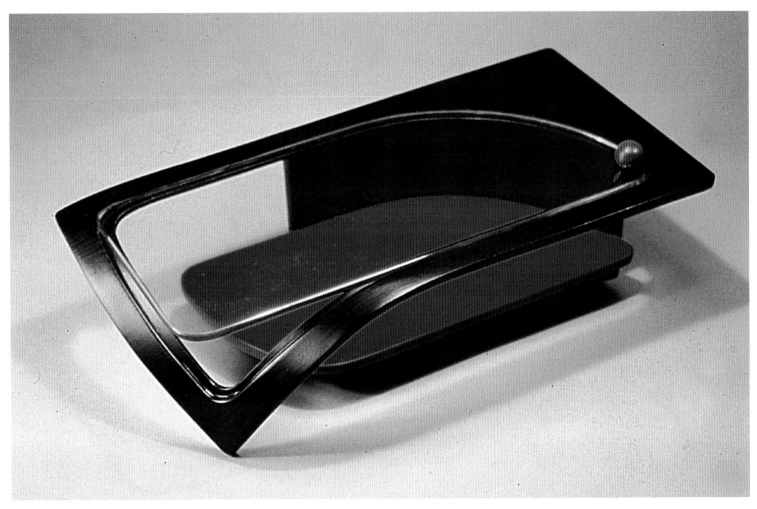

TEA TABLE
WOOD, GLASS, ETC.
1994
PATENT BY WEN'S

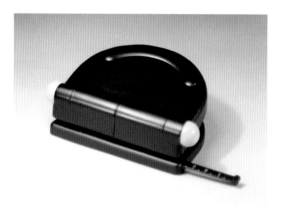

PUNCH
ABS
1993
PATENT BY COMPANION

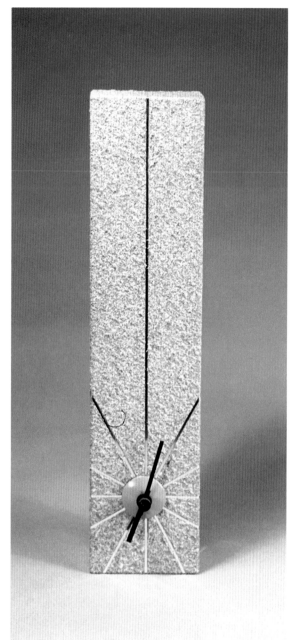

CLOCK
STONE, STEEL, ETC
1993
PATENT BY WEN'S

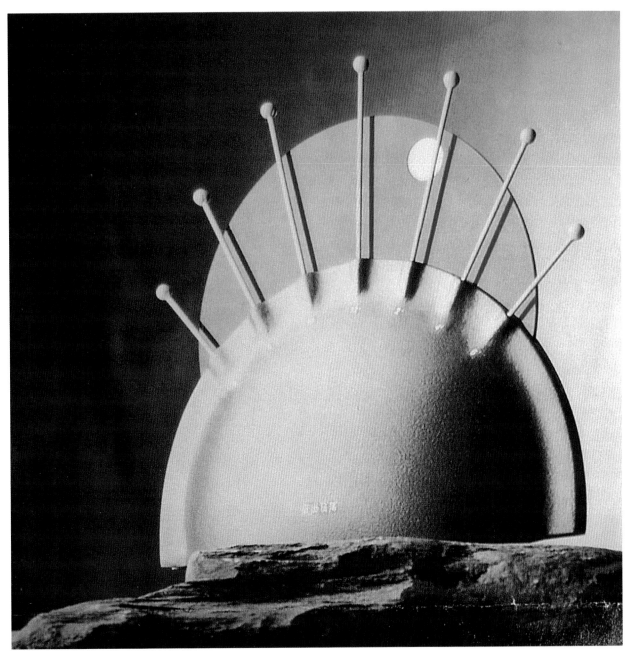

SUNRISE & SUNSET (CLOCK)
BRASS & PLASTIC
1993
PATENT BY WEN'S

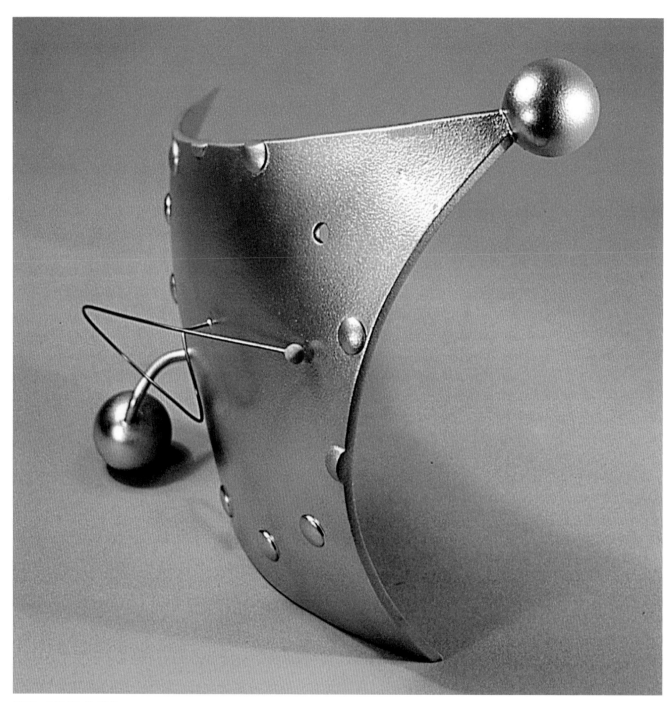

TIME = SPACE, CLOCK
CASTING METAL
1993
PATENT BY WEN'S

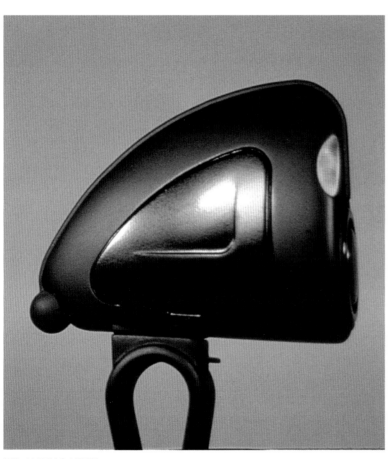

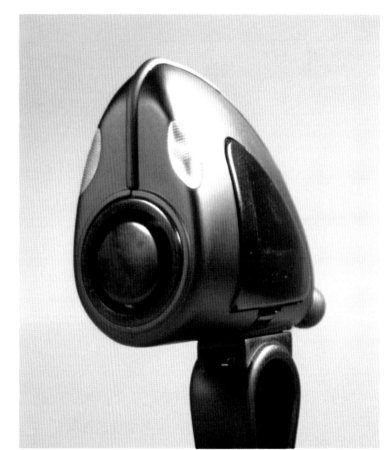

BIC. ALARM & LIGHT
RUBBER & PLASTIC
1993
PATENT BY KUJI

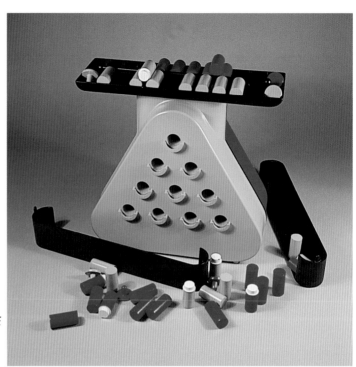

MENTAL WARFARE
ABS
1994
PATENT BY WEN'S

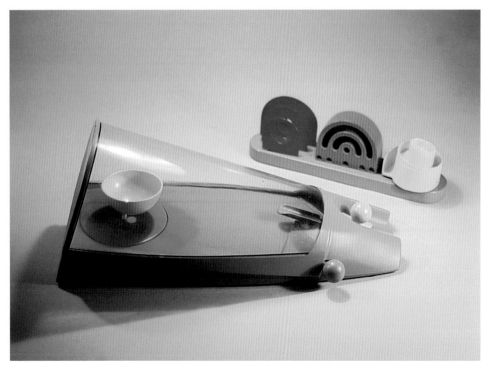

TARGET SHOOTING
INJ. M. ABS & ACRYLIC
1993
PATENT BY WEN'S

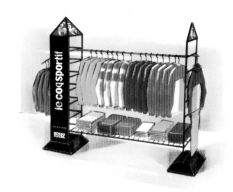

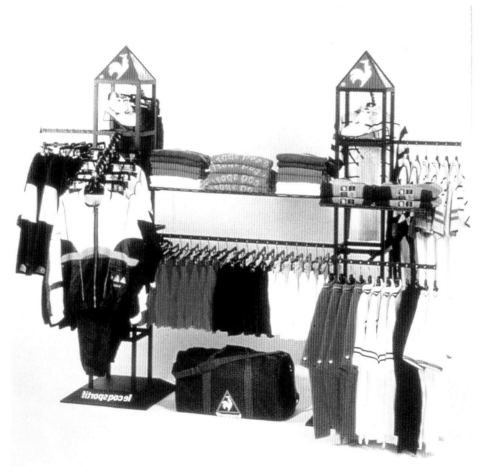

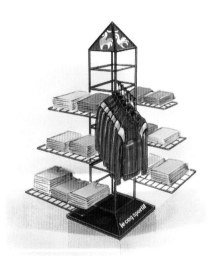

CLOTHES DISPLAY
METAL TUBE
1991
PATENT BY COGSPORTIF

CLOTHES DISPLAY SERIES
WOOD + METAL
1991
PATENT BY CONCEPTUAL

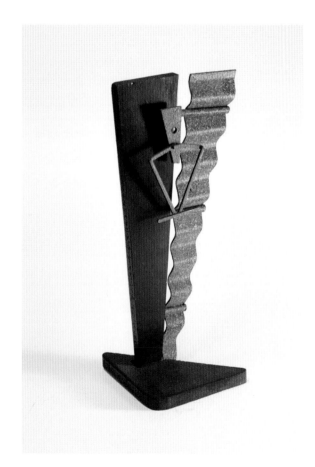

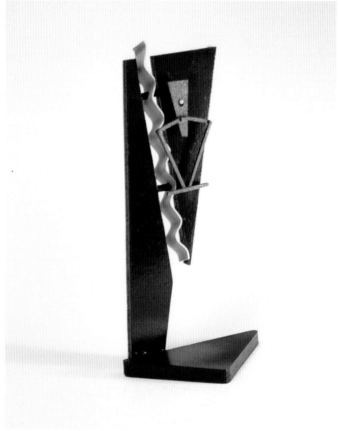

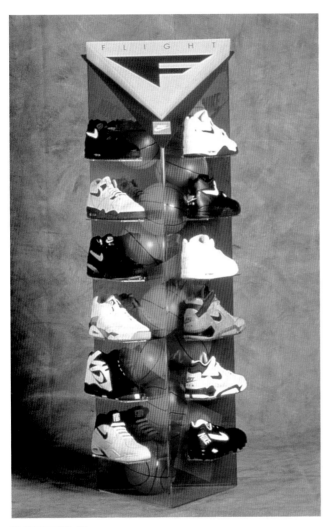

SHOES DISPLAY
PLEXI BOARD
1990
PATENT BY NIKE

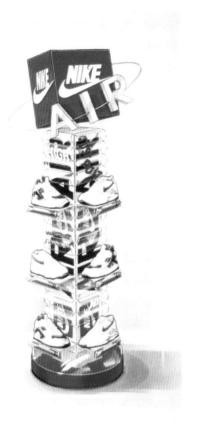

SHOES DISPLAY
WOOD, METAL, PVC, ETC.
1990
PATENT BY NIKE

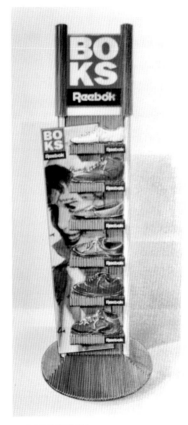

SHOES DISPLAY
WOOD, CORRUGATED PAPER, ETC.
1990
PATENT BY REEBOK

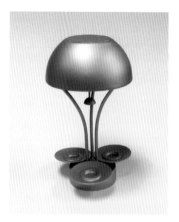

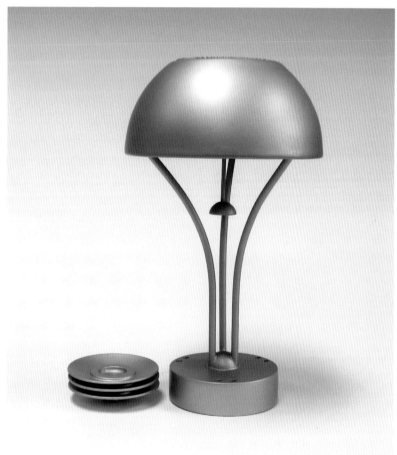

SMOKING
INJ. ABS, METAL CHROME
1990
PATENT BY WEN'S

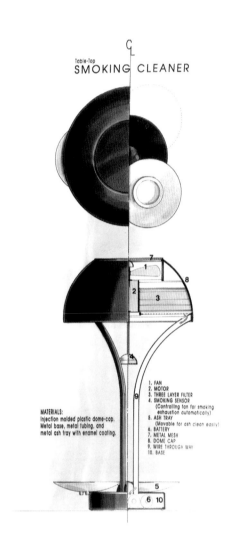

Table-Top
SMOKING CLEANER

MATERIALS:
Injection molded plastic dome-cap.
Metal base, metal tubing, and
metal ash tray with enamel coating.

1. FAN
2. MOTOR
3. THREE LAYER FILTER
4. SMOKING SENSOR
 (Controlling fan for smoking
 exhaustion automatically)
5. ASH TRAY
 (Movable for ash clean easily)
6. BATTERY
7. METAL MESH
8. DOME CAP
9. WIRE THROUGH WAY
10. BASE

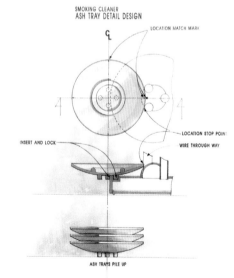

SMOKING CLEANER
ASH TRAY DETAIL DESIGN

LOCATION MATCH MARK

LOCATION STOP POINT

INSERT AND LOCK

WIRE THROUGH WAY

ASH TRAYS PILE UP

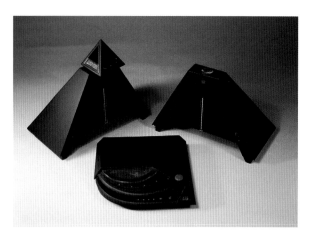

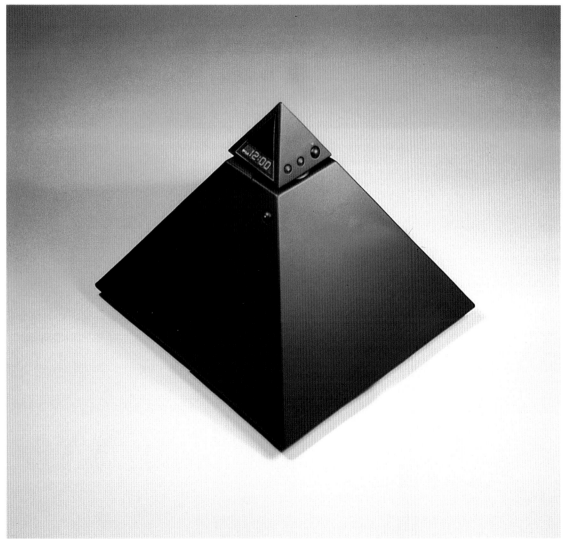

CD PLAYER W/ SPEAKERS
INJ. M. ABS & ACRYLIC
1989
PATENT BY WEN'S

BLENDER
INJ.M. ABS
1988
PATENT BY ROBESON

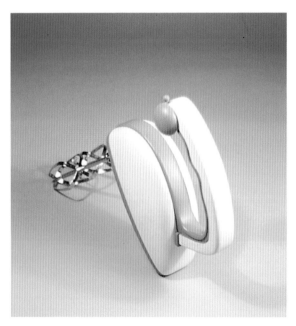

BLENDER
INJ.M. ABS
1986
PATENT BY ROBESON

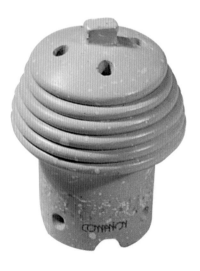

POTPOURRI
CERAMIC, METAL, ETC.
1987
PATENT BY ROBESON

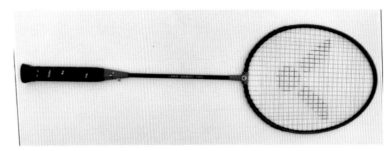

BADMINTON RACKET
CARBON, ZINC ALLOY, ETC.
1985
PATENT BY VICTOR

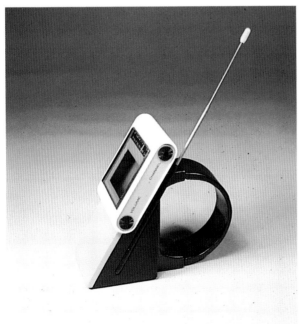

2" PORTABLE CTV
INJ. M. ABS
1986
PATENT BY WEN'S

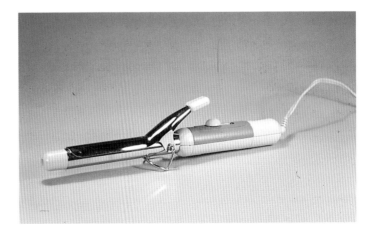

HAIR IRON
METAL, ABS, ETC.
1987

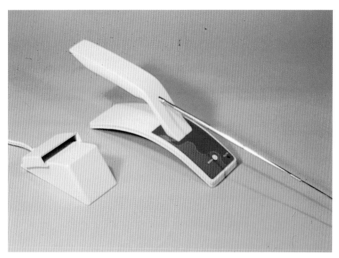

PHONE SET
ABS
1985
PATENT BY WEN'S

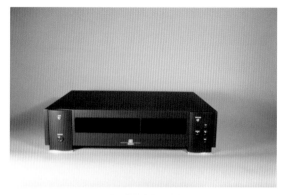

CDI PLAYER
ABS
1986
PATENT BY SAMPO

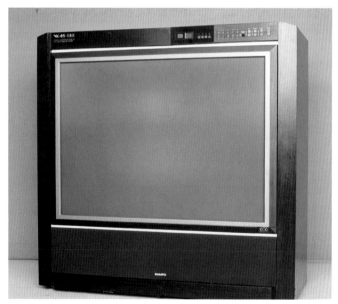

45" PROJECT CTV
PLASTIC MASK, WOODEN CABINET
1984
PATENT BY SAMPO

19" DIGITAL CTV
ABS, GLASS, ETC.
1985
PATENT BY SAMPO

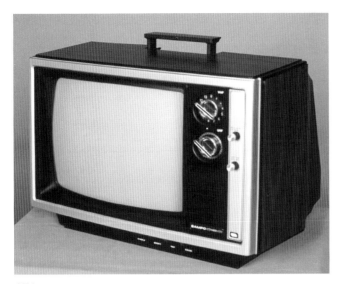

CTV
INJ.M. ABS
1980
PATENT BY SAMPO

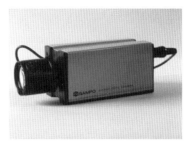

CCTV CAMERA
METAL, ABS, ETC.
1981
PATENT BY SAMPO

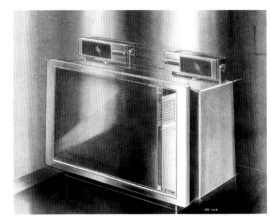

CTV
INJ.M. ABS
1982
PATENT BY SAMPO

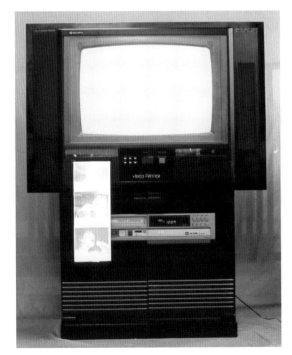

CTV PRINTER
INJ.M. ABS, WOODEN RACK
1983
PATENT BY SAMPO

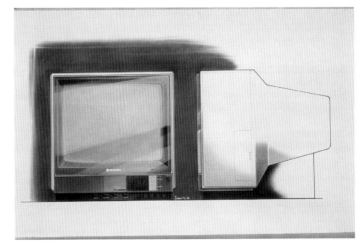

13"CTV
ABS CAB. W/ GLASS
1984
PATENT BY SAMPO

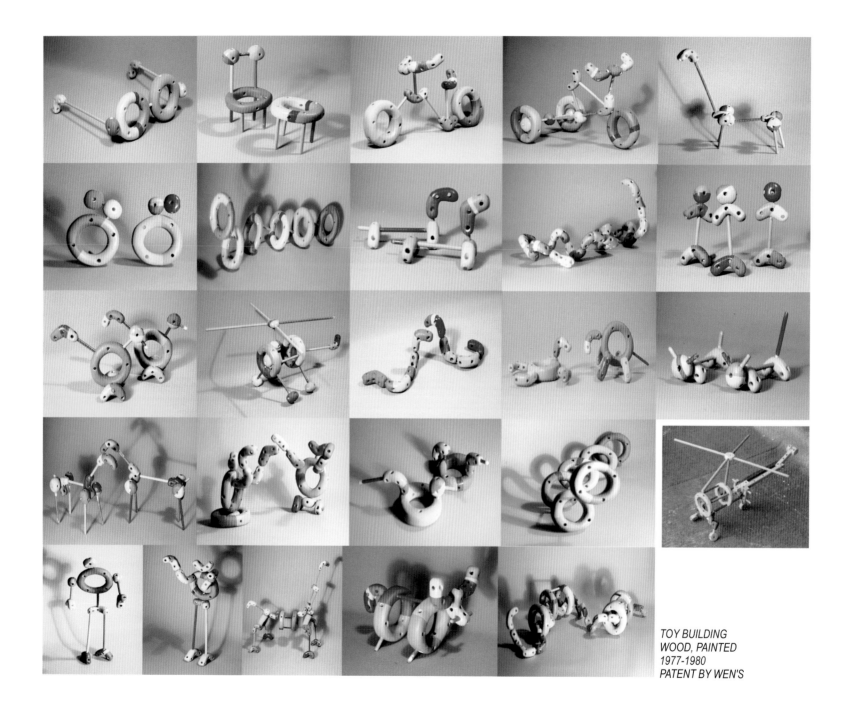

TOY BUILDING
WOOD, PAINTED
1977-1980
PATENT BY WEN'S

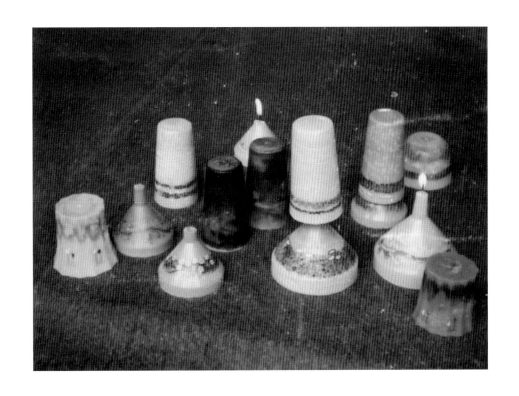

ART CANDLE
WAX, OIL PAINT, ETC.
1979

T—A R T

A BRAND NEW YOU

Guardian

SYNVISION

Brilliant Bamboo Craft

CREATIVE SQUARE

國家圖書館出版品預行編目（CIP）資料

呂豪文產品設計 / 呂豪文著. ——
初版. —— 新北市：全華圖書，2011.09
面；　公分
ISBN 978-957-21-8276-5(平裝)
1. 產品設計 2. 工業設計 3. 作品集
964　　　　　100019906

呂豪文產品設計

作者／呂豪文

發行人／陳本源

出版者／全華圖書股份有限公司

郵政帳號／ 0100836-1 號

印刷者／宏懋打字印刷股份有限公司

圖書編號／ 10402

初版一刷／ 2011 年 9 月

定價／新臺幣 1000 元

ISBN ／ 978-957-21-8276-5

全華圖書／ www.chwa.com.tw

全華網路書店 Open Tech ／ www.opentech.com.tw

若您對書籍內容、排版印刷有任何問題，歡迎來信指導 book@chwa.com.tw

臺北總公司（北區營業處）
地址：23671 新北市土城區忠義路 21 號
電話：(02)2262-5666
傳眞：(02)6637-3695、6637-3696

南區營業處
地址：80769 高雄市三民區應安街 12 號
電話：(07)862-9123
傳眞：(07)862-5562

中區營業處
地址：40256 臺中市南區樹義一巷 26 號
電話：(04)2261-8485
傳眞：(04)3600-9806

（請由此線剪下）

歡迎加入 **全華會員**

● **會員獨享**

會員享購書折扣、紅利積點、生日禮金、不定期優惠活動…等。

● **如何加入會員**

填妥讀者回函卡直接傳真 (02) 2262-0900 或寄回，將由專人協助登入會員資料，
待收到 E-MAIL 通知後即可成為會員。

如何購買 **全華書籍**

1. 網路購書

全華網路書店「http://www.opentech.com.tw」，加入會員購書更便利，並享有
紅利積點回饋等各式優惠。

2. 全華門市、全省書局

歡迎至全華門市（新北市土城區忠義路 21 號）或全省各大書局、連鎖書店選購。

3. 來電訂購

(1) 訂購專線：(02) 2262-5666 轉 321-324
(2) 傳真專線：(02) 6637-3696
(3) 郵局劃撥（帳號：0100836-1 戶名：全華圖書股份有限公司）
※ 購書未滿一千元者，酌收運費 70 元。

OpenTech 全華網路書店 .com.tw

全華網路書店 www.opentech.com.tw
E-mail: service@chwa.com.tw

※ 本會員制如有變更則以最新修訂制度為準，造成不便請見諒。

親愛的讀者：

感謝您對全華圖書的支持與愛護，雖然我們很慎重的處理每一本書，但恐仍有疏漏之處，若您發現本書有任何錯誤，請填寫於勘誤表內寄回，我們將於再版時修正，您的批評與指教是我們進步的原動力，謝謝！

全華圖書 敬上

勘 誤 表

書 號			書 名	作 者
頁 數	行 數		錯誤或不當之詞句	建議修改之詞句

我有話要說：（其它之批評與建議，如封面、編排、內容、印刷品質等...）